GALAXY
WATERCOLOR

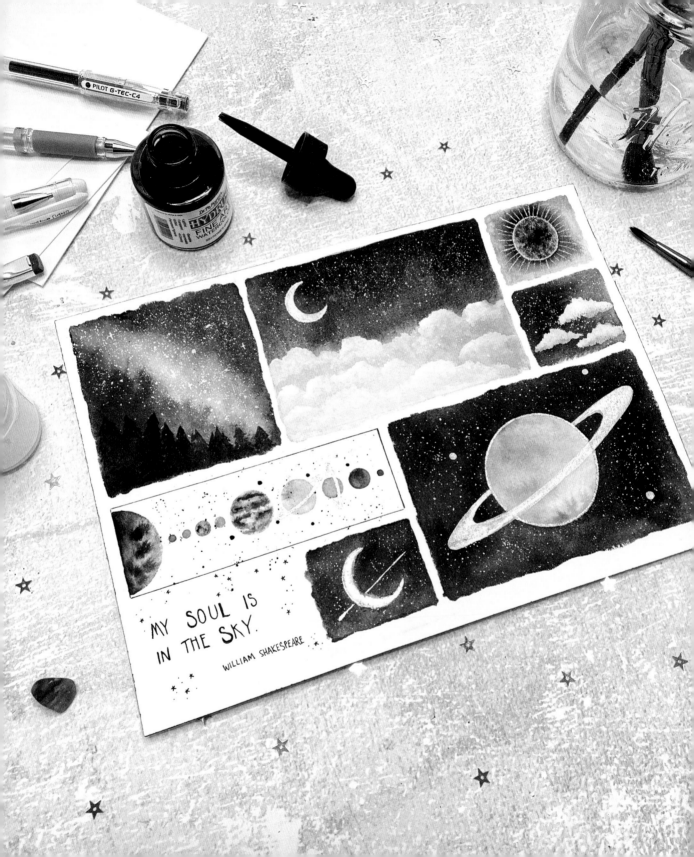

GALAXY WATERCOLOR

Paint the Universe with 30 Awe-Inspiring Projects

SOSHA DAVIS

creator of sosha creates

PAGE STREET
PUBLISHING CO.

First published in 2021 by

Page Street Publishing Co.

27 Congress Street, Suite 105

Salem, MA 01970

www.pagestreetpublishing.com

Distributed by Macmillan, sales in Canada by The Canadian Manda Group.

25 24 23 22 21 1 2 3 4 5

ISBN-13: 978-1-64567-296-8

ISBN-10: 1-64567-296-4

Library of Congress Control Number: 2020948797

Cover and book design by Molly Kate Young for Page Street Publishing Co.

Art and photography by Sosha Davis

Printed and bound in the United States

"It has been said that astronomy is a humbling and character-building experience. There is perhaps no better demonstration of the folly of human conceits than this distant image of our tiny world. To me, it underscores our responsibility to deal more kindly with one another, and to preserve and cherish the pale blue dot, the only home we've ever known."

—Carl Sagan, *Pale Blue Dot: A Vision of the Human Future in Space*

Dedication

This book is dedicated to my children, Jaxon and Jori, for bringing me closer to the meaning of life and opening my eyes to the natural universe we exist in.

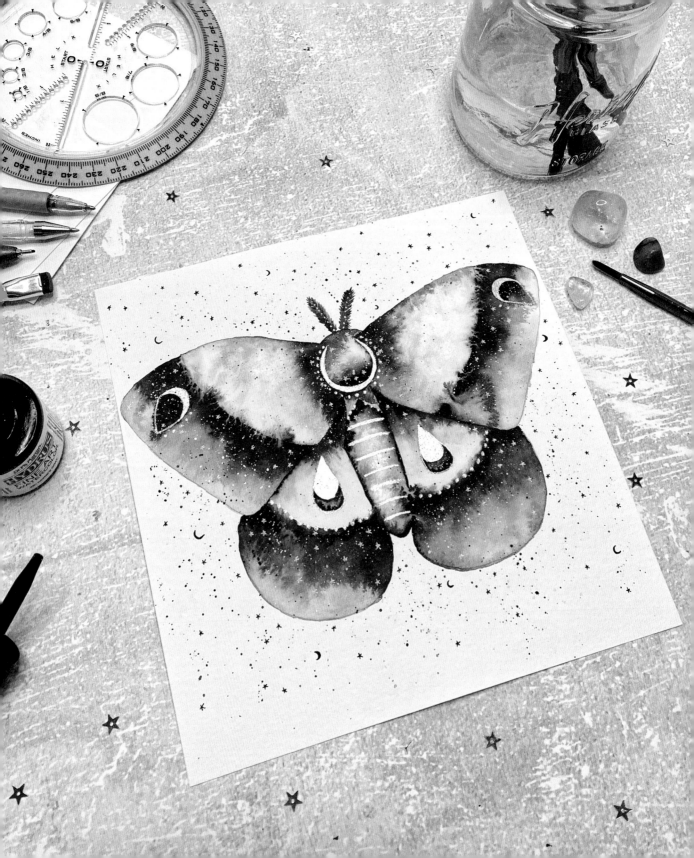

TABLE OF CONTENTS

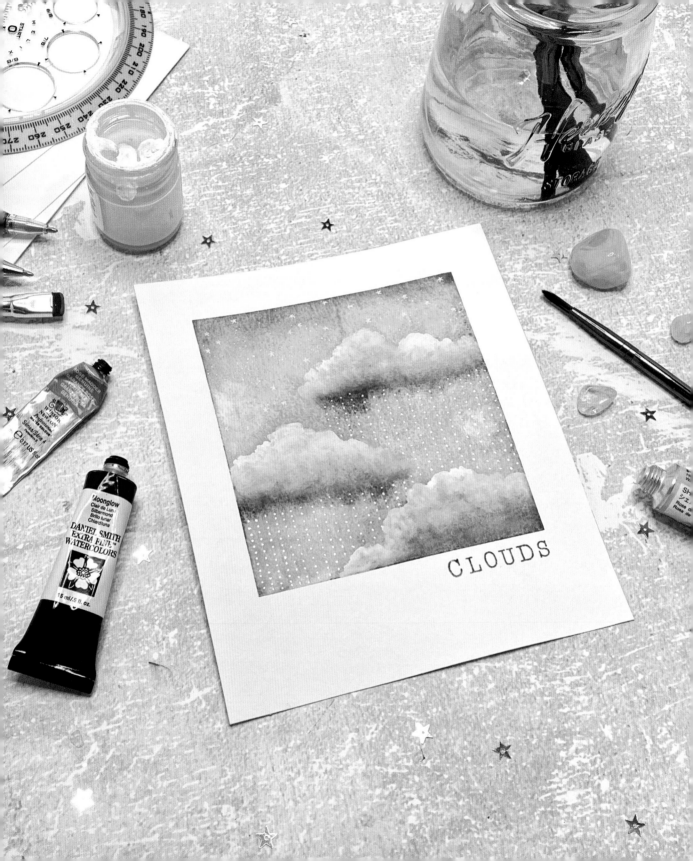

CLOUDS

INTRODUCTION

Hello, friend! Thank you for choosing my book. I'm excited to share with you how I create some of my dreamy cosmic art. I'm a classic Pisces sun sign—artistic, highly imaginative and a big dreamer—and I've loved to paint ever since I was a child. Pisces is one of the water element signs of the zodiac, so perhaps it's only natural that I became drawn to watercolors in college. The process of painting with them and how they swirl around in the water and on the paper has always been mesmerizing to me. It is a very dreamy, relaxing medium.

Watercolors are not only a significant part of my art but also how I connect to the world around me. As I've gotten older, I've felt a profound need to connect to nature and the universe. I look to the cosmos to explain the existence of life, and this has led me on a spiritual journey that manifests itself in my art. I try to create something every day that reflects my love of the cosmos. It's my personal process of exploration, meditation, therapy and creativity.

My artistic style reflects exactly what I dream up in my imagination! It takes time to develop an artistic style, and your style can change as life ebbs and flows. The most significant thing I've learned from finding my style is that you have to paint what you feel and feel what you paint. Forget the end result; it's about the process and being with your art in the moment. When you let go of the need to control the end result, especially with watercolor, your art will showcase how beautiful that process can be.

In this book I provide my secrets to reimagining the cosmos with watercolors. You will learn some basic watercolor techniques that will help you create a variety of foundational backgrounds, and I'll also give you my paint-mixing formulas for the colors I use most often in my paintings. I'll show you step by step how to replicate scenes of the moon, dreamy skies with clouds, planets with a twist and surreal symbols in my airy, ethereal style.

My wish is that you find this book helpful, soothing and dreamy. I also hope that it inspires you to create beyond what I've shown you and helps you find your own creative path.

Sosha Davis

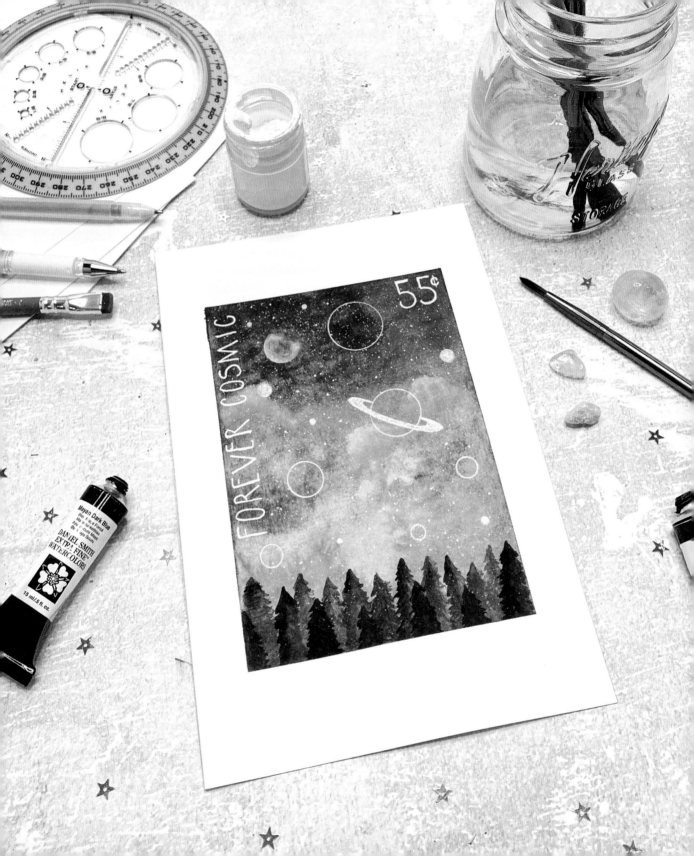

SUPPLIES, TECHNIQUES & PAINT MIXES

SUPPLIES

Paper

There are several different types and brands of water-color papers that can be used for the projects in this book. Hot press, cold press and mixed-media papers are all suitable for watercolor. Hot press paper is smooth without any "tooth" or texture to it, which is good for watercolor applications that use little water. Cold press paper has texture and holds a lot of water for a longer period of time. Mixed-media paper is similar to a thicker sketching or drawing paper and works well for just about any application, wet or dry.

For almost all of the projects in this book, I used Canson®, Winsor & Newton™, and Fluid™ cold press, 140lb (300gsm) watercolor blocks in varying sizes. For one project I also used my handmade journal of mixed-media paper that I folded in half.

Several of these projects are suitable to paint in a journal, and you can easily make your own with about five large sheets of mixed-media paper stapled together in the middle. If you buy a journal to use, make sure it has a heavy paper inside, like a mixed-media or thick watercolor paper.

Lastly, you will use some sticker paper for one of the projects. You can buy full sheets of sticker paper at most craft stores. It is usually located near the personal cutting machines. If you cannot find any whole sheets of sticker paper, you can always use printer labels. I buy my sticker paper from Amazon in 8½ x 11-inch (21.5 x 28–cm) sheets.

Brushes

Like paper, brushes come in all sorts of styles, brands, shapes, sizes and materials. To some artists, a paintbrush is everything, but some of them have a hefty price tag. I try to stay away from natural brushes that are made with animal hair, but it's completely an artist preference. I also stay away from wood-handled brushes because if you leave them in your water dish, over time they start to warp and fall apart. My preferred brushes that I used for all of the projects in this book are from the Zen collection by Royal & Langnickel®. I use round brushes in sizes 2, 4, 6 and 8. I also use a medium round wash brush to lay down water or a wash before I add color. To make stars, I use a very tiny size 0 brush.

Watercolor

For me, watercolor has to be just as beautiful as it is therapeutic. Choosing the right watercolors is important because it can really make or break a piece. Color quality is everything in my opinion. The right color can assist you in painting a great piece, whereas some colors will work against you. Student-grade watercolors are pretty inexpensive, but a lot of them are very basic. Professional-grade watercolors tend to have beautiful gradations of color or bleed beautifully when added to a wash of water.

Many watercolors come in tubes or little pans of dried paint called half pans or full pans. Most colors I use come in tubes, and I hand pour them into half pans. They dry, but adding water will activate the paint. There are also liquid watercolors that work in a similar way on paper as a tubed watercolor. Liquid watercolor is highly pigmented, and a little goes a long way. It spreads beautifully in water, and the colors are very vibrant, for example, the Moon Moth project (page 110) that uses Dr. Ph. Martin's® Payne's Gray liquid watercolor. I use sumi ink in the Starry Night project (page 38), which is something very similar to liquid watercolor. It is a permanent ink but acts a lot like a liquid watercolor.

There are many brands of watercolor paint to choose from, and over time you will learn which works best for you as an artist. Daniel Smith, Dr. Ph. Martin's, Winsor & Newton, Grumbacher® and Holbein are among my favorite watercolor brands. The colors and brands that I used to paint the pieces in this book are noted in the Color Palette list for each project.

Additional Tools

There are several different tools and gadgets I use when creating my art. I will talk about them here so that you know what they are when you see them referenced in the projects throughout the book.

Pens: I use a few different pens to add fine details to my art, such as stars and pops of sparkle. I use a white Uni-Ball Signo™ pen, a silver Uni-Ball Signo™ pen, a metallic gold Sakura Gelly Roll® pen and a silver Pentel Sparkle Pop™ pen.

Circle maker and circle stencil: Both of these tools do almost the same thing, but a circle stencil template allows for larger circles. I use both throughout most of these projects. I use the Helix 6-inch (15-cm) Angle and Circle Maker with a rotating inner disk to make circles of different sizes. It is also a great circle-shaped ruler. A compass can be used to create different-sized circles as well.

Pencil, eraser and rulers: Any basic hard-lead pencil will do. Hard-lead pencils are labeled with an H, for "hard," and softer, darker lead pencils are labeled with a B, for "black." I use a 2H Tombow MONO to make light marks that I need to erase. The lead in a 2B pencil is too soft, and it won't erase well. I also use a Tombow MONO Zero eraser. Have a basic ruler on hand as well. I use a metal straight-edge ruler so that I can also use it to tear paper.

Water container and paper towel: I always fill a couple of jars of water to wash off my paintbrush in between loading it with colors. I use one jar to rinse dark colors and one to rinse light colors. I typically just use mason jars for this, but bowls also work. Have a few paper towels on hand as well to dry off your brush or to wipe away excess paint.

Washi tape or painter's tape: You will need some washi tape or painter's tape for a few of the projects. Both types of tape will peel off your paper without tearing it. If you use anything stronger, you run the risk of tearing your paper. Just use caution whenever removing any tape from your paper so that ripping doesn't occur. I use a range of washi tape sizes: ¼ inch (6 mm), ½ inch (1.3 cm) and ¾ inch (2 cm).

TECHNIQUES

There are three basic techniques that are commonly used in watercolor: wet on wet, wet on dry and dry on dry. I use the wet-on-wet technique for most of the projects in this book, but I also use the wet-on-dry technique for a few.

Wet on wet is combining a wet paper with a wet brush. Load your brush with clean water and brush it across your paper to get it wet. Then dip your brush into water again and then into your color to wet the color. With your brush loaded with color, apply the paint to your wet paper.

Wet on dry is applying a wet brush loaded with paint to a dry piece of paper. For example, dipping your brush into water and then into your color, loading your brush with color and then applying your wet brush straight to the dry paper to paint. With this technique, the watercolor doesn't run as much and won't be as transparent, as it results in a heavier application of paint. You would have to use additional water on your brush to get your colors to move around the paper.

Dry on dry is basically taking colors directly from a tube of paint and brushing them right onto dry paper with no water. Because the brush is dry, this technique doesn't work with dried half pans. It creates a very thick application, almost like an acrylic paint. I personally don't use this technique for watercolor. To me, it almost defeats the purpose of using watercolor in the first place, but it can be good for adding texture.

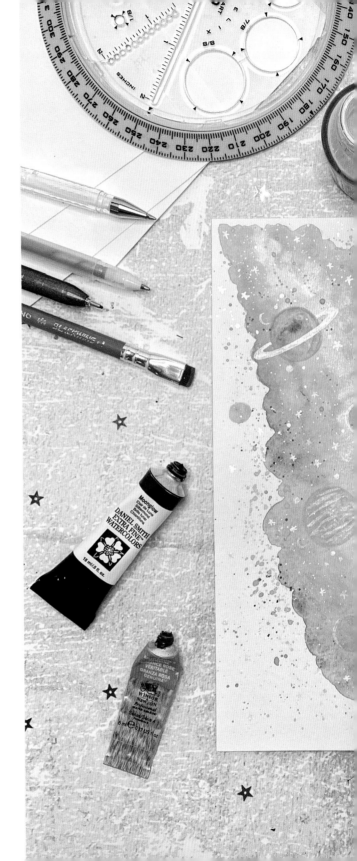

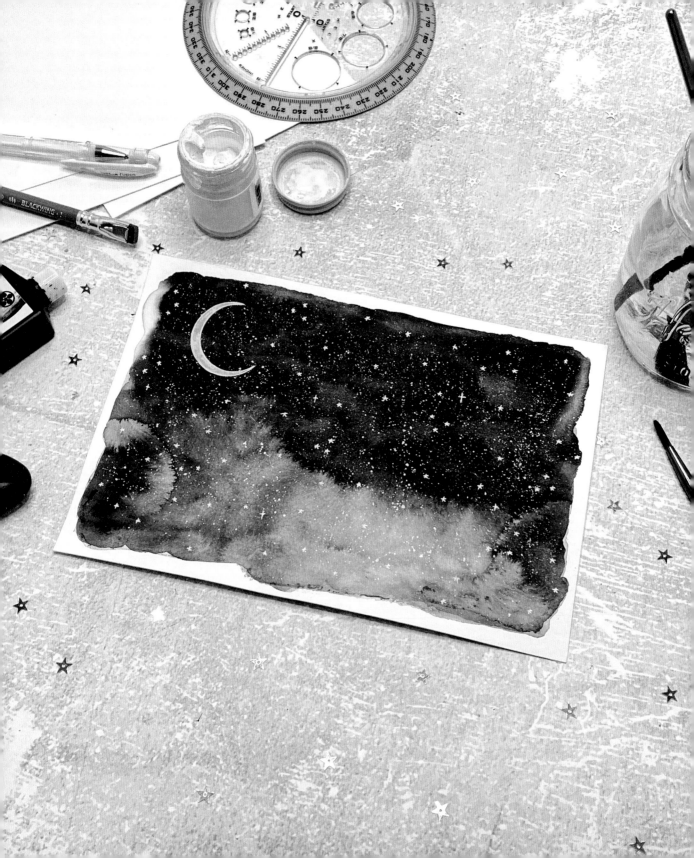

Washes and Saturation

Throughout the book you will hear me talk about washes and layering your watercolor to achieve more color saturation. When I refer to a wash, I am referring to the wet-on-wet technique, in which you put down a layer of clean water with a clean brush and then go in with a wetted color on your brush on the wet area of the paper. This creates a wash of color because it isn't as saturated as color applied directly to dry paper. With a wash, you are able to build up layers of paint that will give you the saturation of color you are looking for. It also allows for a beautiful blend and bleed of the colors that is characteristic of watercolor.

Tips and Tricks

If this is your first time attempting watercolor, here are a few tips to remember while you're working.

- Always have at least two containers for water to clean your brushes in between applications of paint. I use one for rinsing off darker colors and one for rinsing off lighter colors. It's also a good idea to have a third container of just clean water that you can use for washes, but this is not completely necessary if you are only working on one piece at a time.

- It's important to wash off your brush in between colors. If you don't rinse off your brush before loading it with a new color, you're going to have some muddy colors. I typically wash off my brush in water, wipe it off on a paper towel and then wet the brush and load up my color.

- Watercolor loves water! Always add water to your dry watercolor to activate it before you begin to paint. I dip my brush in water and then add it to my color this way. You could always use a small eye dropper to add in a few drops of water to each color if you prefer.

- Watercolor can be very forgiving and easy to change if you make a mistake. Even after you've put down some color and it's dried, most watercolor can be reactivated on paper with some clean water, and you can remove it by dabbing up the water and color with a dry paper towel. I don't recommend doing this over an entire piece, but if you get paint in a small area you didn't intend to, you can remove it with this technique. This is another benefit of working in layers with watercolor. A light layer of color can easily be removed if a mistake is made.

- Watercolor requires some letting go! Don't be restrictive with it, and don't expect it to be an exact replica of perfection! It's a beautiful medium, and in my opinion, there are no mistakes when using it. Watercolor has a mind of its own, and when you let the paint behave naturally, the results can be beautiful and relaxing. In other words, if your projects don't turn out just like the projects in this book, don't even fret. It's about the process, which is a part of you.

SOSHA'S MIXES

I will refer to "my mixes" throughout the projects in this book. These are the color combinations I use in most all of my pieces to achieve specific colors. I like to mix up these color combinations just before using them on a palette, but if you like to plan ahead, you can mix them up on a palette and transfer them to a half pan or a container until you are ready to use them.

If for any reason you are unable to acquire the base colors I've outlined for a mix, I've provided some alternative mix formulations that don't include any specific brands, so feel free to use what you have that is closest to the color description, or purchase what you need in any brand you choose.

You may need to adjust these mixes by adding more of one color or more white. I recommend always doing a little test swatch of a mix on a piece of scrap paper before you start painting a project.

My store of choice to buy all of my watercolors is Blick Art Materials. They carry everything, are very reasonably priced and shipping is reasonable if you order online. Amazon is a close second, but I find the pricing is slightly higher. If you like going to the store instead, I recommend Michaels craft stores, as they are everywhere throughout the United States and carry a good selection of watercolor paints.

My Pink Mix:

Mix equal parts Winsor & Newton Rose Madder Genuine, Holbein Shell Pink and Daniel Smith Buff Titanium. Then add in a few dabs of Daler-Rowney Aquafine Gold for a little added sparkle.

Alternative: Mix 1 part pink, 2 parts white and a dab of gold

My Vanilla Mix

Mix 2 parts Daniel Smith Buff Titanium with 1 part Dr. Ph. Martin's Bleedproof White or any opaque white watercolor, such as Winsor & Newton Titanium White.

Alternative: Mix 1 part yellow, 2 parts white and a dab of brown

My Peach Mix

Combine 2 parts My Pink Mix, 1 part Daniel Smith Raw Sienna and 2 parts My Vanilla Mix. You can adjust the color if it's too pink or too yellow by adding in more or less of My Pink Mix or Raw Sienna.

Alternative: Mix 1 part pink, 1 part yellow, 2 parts white, a dab of gold and a dab of brown

My Teal Mix

Mix equal parts Daniel Smith Cascade Green and Daniel Smith Phthalo Turquoise. Add in a dab or two of Daler-Rowney Aquafine Gold for some added sparkle.

Alternative: Mix 1 part turquoise, 1 part green and a dab of gold

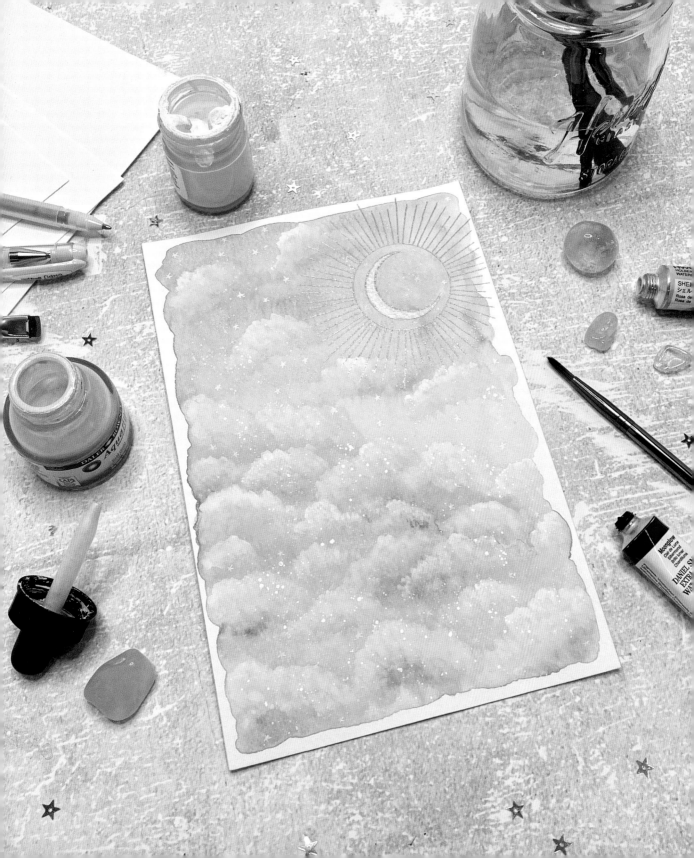

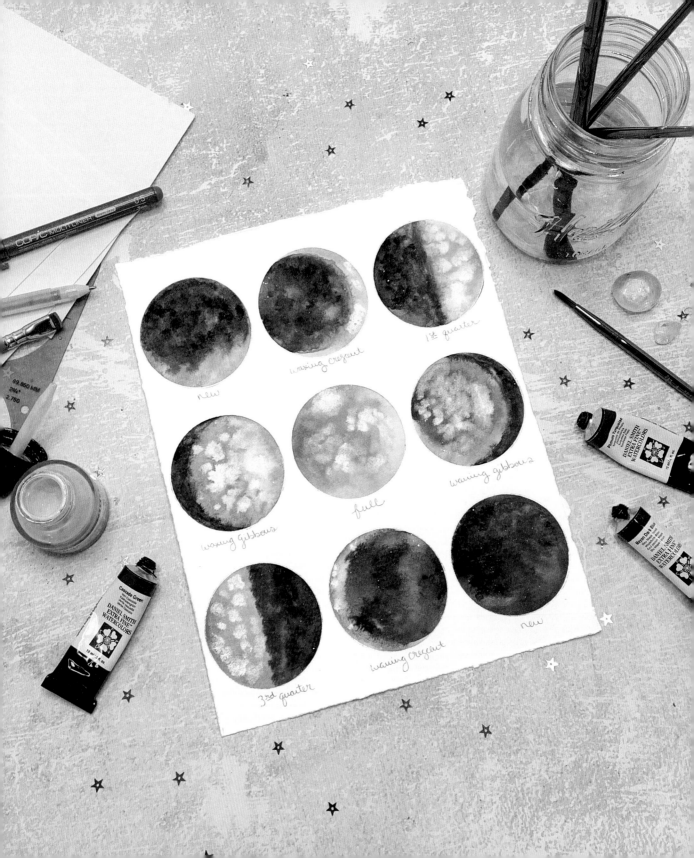

MAGICAL MOONS

One of my favorite objects to paint is the moon. I love the variety it offers as a subject because it changes every day. The moon can be painted as abstract or technical as you wish and will still turn out beautifully. Watercolor is the best medium to use when painting the moon because achieving the variations of color that reflect the moon's surface feels effortless. Watercolor also lends itself well to creating very dreamy works of art. One of my favorite projects in this chapter is the Floral Crescent Moon (page 31). I created it after watching an artist paint flowers very freely and abstractly as she listened to one of my favorite songs, "Clair de Lune" by Debussy. Put on some of your favorite music, and let's get to painting the moon!

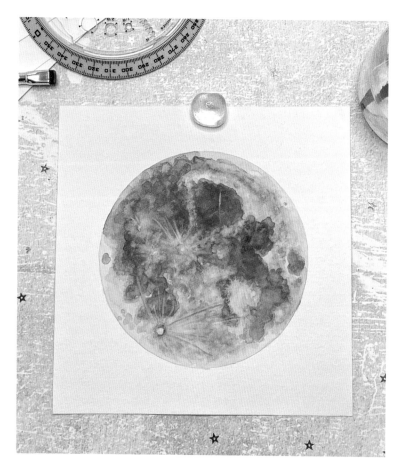

STRIKING FULL MOON

This project is a great opportunity to take an in-depth look at the moon. Take some time to gaze at the moon on a clear night and take note of some of its darker spots, or study a picture of the moon. Observing the moon and looking closely at the details on its surface will help you master painting it. You'll find that as the watercolor flows on your paper, it will leave spots of your moon lighter and some darker that blend together without effort, re-creating what you observed.

Supplies

8 x 8" (20 x 20-cm) sheet watercolor paper

Ruler

Pencil and eraser

Circle marker tool

Paintbrushes, sizes 6 and 8

Heat tool or hair dryer (optional)

Color Palette

 Grumbacher Academy Charcoal Gray

2

3

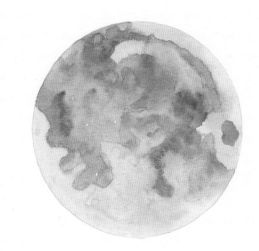

4

1. Find the middle of your paper by measuring half the length on each side and lightly drawing a horizontal line. Then measure half the width on each side and lightly draw a vertical line across the page. Where the lines connect in the middle is the center of the paper.

2. Use the guidelines to draw or trace a 6-inch (15-cm) circle in the middle of your paper with a circle maker tool or compass.

3. Erase the guidelines and sketch in some of the dark spots on the moon. If needed, use a picture of the moon for reference.

4. Add some Charcoal Gray to a palette. You will add varying amounts of water to create gradients of the color. Add more water to the Charcoal Gray to get a lighter color or less water for a darker color. With a size 8 brush, use the wet-on-dry technique (page 13) to paint your moon with a layer of light Charcoal Gray. While the light layer of color is still wet, focus on the dark areas you sketched with your pencil and apply a darker shade of the color there.

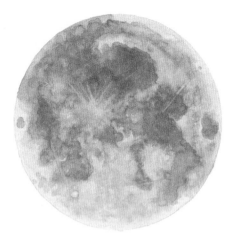

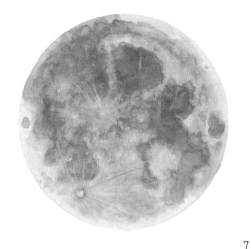

6

7

5. Let your first layer of paint dry completely. You can use a heat tool or hair dryer, but be careful because a heat tool will burn your paper if you get it too close and a hair dryer can blow your paint across the page. It's best to have patience and let your watercolor dry naturally.

6. Next, go back in with a size 6 brush and some more Charcoal Gray to refine the darker areas that you sketched. Pay close attention to details such as craters and the lines the moon has. To create a lighter area, apply a clean brush loaded with clean water to the spot you want to lighten and remove some of the watercolor by dabbing it up with a paper towel.

7. You can repeat these steps of adding or removing color until you've refined your moon to your liking.

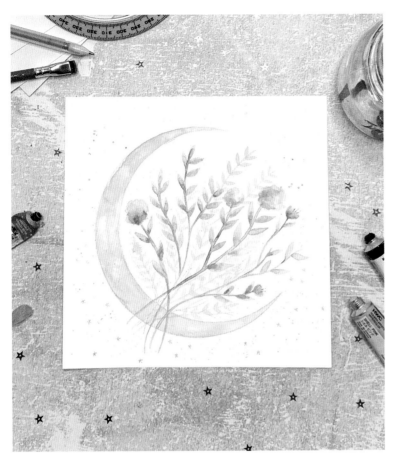

CRESCENT MOON WITH BOTANICALS

One night I was gazing at the crescent moon through my telescope, and the moon was positioned just behind a few of the trees in my backyard. The branches of the tree were visible in front of the moon in the lens of my telescope, and that view is what inspired this project.

The crescent shape is unique to the moon. No other object in our sky that we are able to see with the naked eye takes on this shape. It's another one of my favorite phases of the moon to paint. You will paint a simple crescent moon in this project, giving it some shimmer and decorating it with some simple botanicals.

Supplies

8 x 8" (20 x 20-cm) sheet watercolor paper

Ruler

Pencil and eraser

Circle marker tool

Paintbrushes, sizes 0, 4 and 6

Metallic gold pen (I used a Sakura Gelly Roll Pen)

Color Palette

My Pink Mix (page 16)

Daniel Smith Moonglow

2

3

4

1. Find the middle of your paper by measuring half the length on each side and lightly drawing a horizontal line. Then measure half the width on each side and lightly draw a vertical line across the page. Where the lines connect in the middle is the center of the paper.

2. Use the guidelines to lightly draw or trace a 6-inch (15-cm) circle in the middle of your paper with a circle maker tool or compass, then erase the guidelines.

3. Place your circle maker tool or compass over the circle you just drew, then slide it to the right about ½ inch (1.3 cm). Lightly draw or trace the left half of a new circle to create a crescent shape inside the first circle.

4. Erase the outer right edge of the first circle and any lines that extend beyond the points of the crescent moon. Next, using the wet-on-wet technique (page 13), load a size 6 brush with My Pink Mix and fill in your crescent moon with a wash of color.

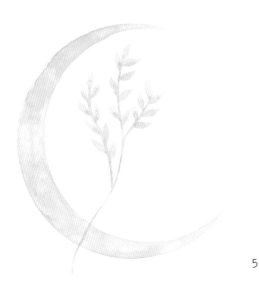

5

5. After it dries, begin painting in some leafy branches with My Pink Mix. Remember—these don't have to be perfect! With a size 6 brush, paint a line from just under the bottom of your crescent moon to the middle of the page. Paint two more lines coming off the first line about halfway up. With a size 4 brush, paint leaves coming off those branches on each side. To paint an easy leaf, load your brush with color and press it down on the paper next to one of the lines you just drew to create the thicker part of the leaf. Slide the brush just a hair away from your branch and then while still sliding, lift up your brush to create the tip or point of a leaf. You can practice this technique on a scrap piece of paper first. While the leaves are still wet, dab a little bit of Moonglow in the middle of the leaves to vary the color slightly.

6. Continue adding more botanicals by repeating Step 5 to create stems and leaves. Paint a few stems without leaves and add flowers to the top of them. Then add a few leaves to the stems with flowers. The flowers do not have to be perfect; they should be loosely painted and abstract. For these flowers, I made a splotch of paint by moving the color around in an imperfect circle. I also added another flower by making an imperfect half circle with a few petals coming out of the top. To give some of the stems and leaves the appearance of depth, add more water to your color to create a lighter shade to fill in some of the spots between stems with additional botanicals. After your botanicals have dried, go back in and refine some of the leaves and flowers by adding another layer of paint, but keep some of the stems with leaves light pink so it appears they are in the background. Add details such as the pistils in the middle of flowers or additional stems and leaves with My Pink Mix and a little bit of water.

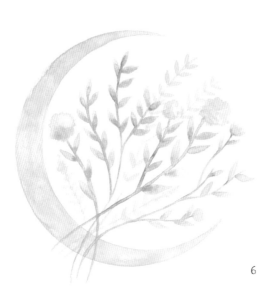

6

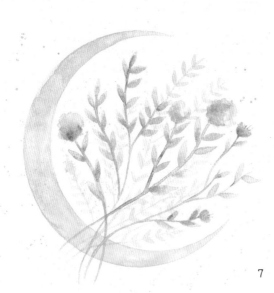

7

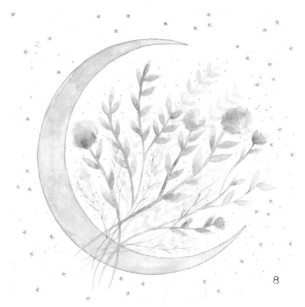

8

7. Next, take a size 0 brush and load it with some of the paint you used for the initial crescent moon wash, then lightly tap your brush to flick the paint over your painting, creating a star effect. It is helpful to add a bit of water to the paint when loading it onto the brush, but do not add too much or your stars will end up too big.

8. After your stars dry, use a gold metallic pen to add some hand-drawn stars. With the same pen, add in some more branches through the botanicals and outline the crescent moon. Finally, add some dots of gold throughout the piece for an added touch of shimmer.

MOON PHASE WALL ART

When I can't find just the right piece for my wall, sometimes I like to make my own art to frame and display. This project is one of those pieces. It's a very simple piece that you can frame or put in a journal to look back on. This project is also a great way to familiarize yourself with the phases of the moon. It's amazing to look at how the moon changes every day in the sky, so I encourage you to track it for a month to see for yourself. It will bring some inspiration to your art.

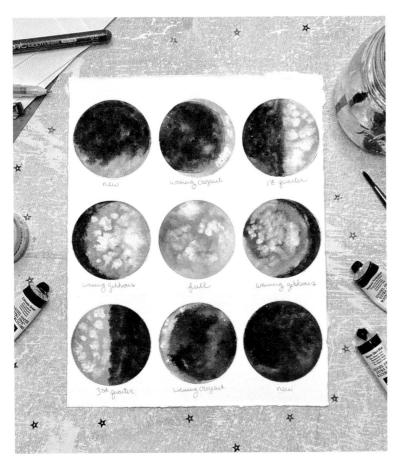

Supplies

Scissors (optional)

Ruler

9 x 12" (23 x 30.5–cm) sheet watercolor paper

Pencil and eraser

Circle stencil tool

Paintbrushes, sizes 6 and 8

Metallic gold pen (I used a Sakura Gelly Roll Pen)

Warm gray ink pen (I used a Copic Multiliner Pen)

Color Palette

 Daniel Smith Mayan Dark Blue

 My Teal Mix (page 16)

 Daler-Rowney Aquafine Gold

1. Cut your sheet of watercolor paper down to 8 x 10 inches (20 x 25 cm). For an added touch, instead of scissors, use a straight-edge ruler and tear your paper down to size. This will create a deckled edge or torn-paper effect.

2. Create a rough nine-square grid on your paper by lightly sketching guidelines with a pencil. Make two vertical lines at the 2⅔-inch (7-cm) and 5⅓-inch (13.5-cm) marks on a ruler and two horizontal lines at the 3⅓-inch (8.5-cm) and 6⅔-inch (17-cm) marks on a ruler. Don't get too hung up on making them exact. Sometimes it can be hard to find these exact measurements on a ruler, so just make your best guess.

3. Next, use a circle stencil tool to make a 2¼-inch (6-cm) circle in the center of each square. You'll want to position them in the middle of each square because later we will write in the phases of the moon below the circles.

4

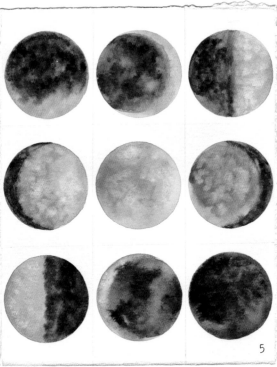

5

4. Next, turn the circles into nine moon phases using your circle stencil tool and a ruler. Your moon phases should go in order from left to right, starting with a new moon in the top left square and ending with a full moon in the bottom right square. Refer to the example image of the moon phases or find a moon phase image on the internet to reference.

5. Using the wet-on-wet watercolor technique (page 13), begin painting your moons with a size 8 brush. Apply a wash of water to your first circle, and then load your brush with Mayan Dark Blue and brush it into the circle, letting the water grab the color from your brush. Your first circle is a new moon, so it will be all shadow. Move on to your second moon, and load your brush with water. This time, only apply water to the shadow side of your moon. Then put down Mayan Dark Blue, just as you did for the new moon. While painting your shadows and moons, you can alternate between a size 8 and a size 6 brush, or whatever feels most comfortable to you. Typically, size 8 works well to put down the wash of water, and size 6 works well to put down the color. Work quickly, and then load your brush with water again and brush it into the crescent side of your moon, leaving just a small space of dry paper between the shadow and the crescent.

Load your brush with My Teal Mix and brush it into the crescent. This is where you add in some shimmer by loading your brush with Gold paint and dabbing it onto the wet crescent moon. Still working quickly, take your brush and run it along the crescent shape that borders your shadow to let the colors bleed together slightly. If the moon is already fairly dry, get your brush slightly wet to blend the crescent and shadow. Your colors should slightly bleed into one another. Repeat these steps for the remaining moon phases. Remember that your full moon should be painted entirely with My Teal Mix because there is no shadow.

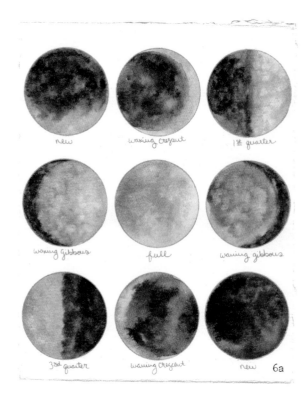

new · waxing crescent · 1st quarter

waxing gibbous · full · waning gibbous

3rd quarter · waning crescent · new

6a

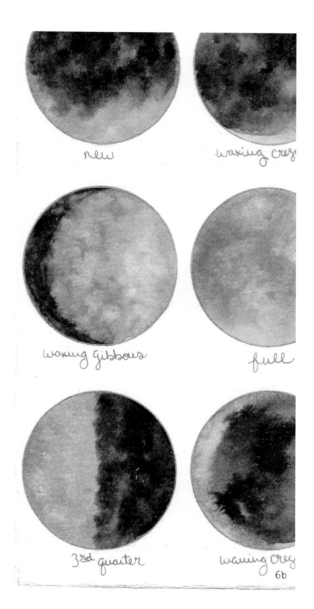

new · waxing cres

waxing gibbous · full

3rd quarter · waning cres

6b

6. After your paint has dried, add a few final touches. Trace around each circle moon phase with a metallic gold pen (6a). Then write the name of each moon phase as centered as you can under each circle with a warm gray ink pen (6b). You could always stamp the names of the moon phases in if you don't like your handwriting, but I think it gives it a nice personal touch when you use your own handwriting. Lastly, erase your grid lines, and the painting is ready to be framed or hung on a wall.

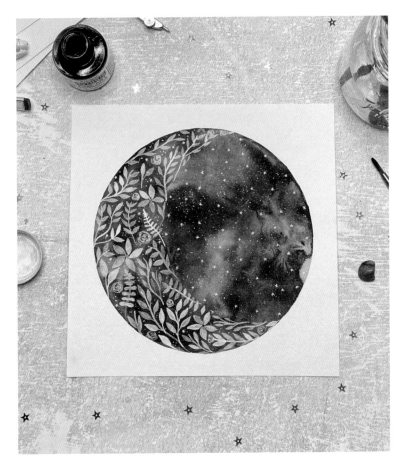

FLORAL CRESCENT MOON

I like to view everything with dreamy eyes! I'm a stargazer, and I'm always looking up at the sky and dreaming. I also love looking at nature, particularly the forest and wildlife that exist right in my backyard, which inspired me to create this project with a moon made of florals and botanicals. It's a relaxing piece to create because it involves loosely painting some leaves and flowers but never overthinking them and how they should look. Try to get into a dreamy state of mind and let your paintbrush guide you!

Supplies

8 x 8″ (20 x 20-cm) sheet watercolor paper

Ruler

Pencil and eraser

6″ (15-cm) circle maker tool

Paintbrushes, sizes 0, 4 and 6

White pen (I used a Uni-Ball Signo Pen)

Color Palette

 Dr. Ph. Martin's Hydrus Payne's Gray

 Dr. Ph. Martin's Bleedproof White

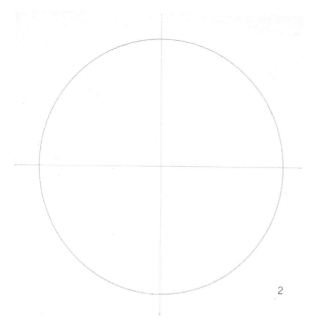

2

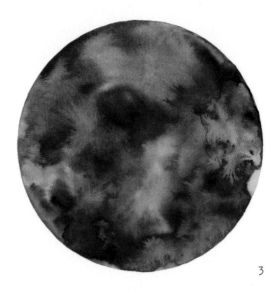

3

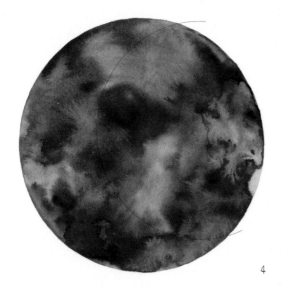

4

1. Find the middle of your paper by measuring half the length on each side and lightly drawing a horizontal line. Then measure half the width on each side and lightly draw a vertical line across the page. Where the lines connect in the middle is the center of the paper.

2. Use the guidelines to trace a 6-inch (15-cm) circle in the middle of your paper with a circle maker tool.

3. Load a size 6 brush with water and wash it over the entire circle. You want the wash to stay inside your circle because that is where the paint will go. Next, load your brush with just a little Payne's Gray—it's very concentrated and a little color goes a long way. If you aren't sure about how much to use, you can always test it out on a scrap piece of watercolor paper. Apply the Payne's Gray to the outer edges of the circle first. Watch the color bleed through the water. Dab more color in areas that need it until your entire circle is painted.

4. After your paint has dried, place your circle maker tool over the painted circle, then slightly offset it to one side. Lightly draw half of a new circle to create a crescent inside the painted circle. Erase any lines that extend beyond the points of the crescent moon.

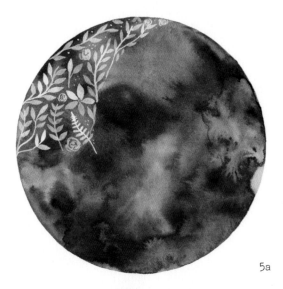

5a

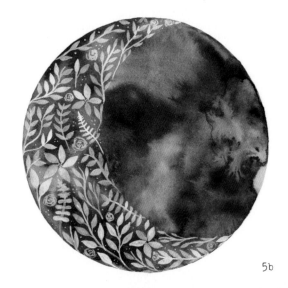

5b

5. Use a size 4 brush to begin painting some botanicals and florals in the crescent with slightly diluted Bleedproof White (5a). Loosely freehand some stems with leaves and a few flower shapes until the entire crescent is filled with botanicals (5b). You can reference the Crescent Moon with Botanicals project on page 25 for instructions on how to paint easy leaves, stems and florals. If you have empty spaces, you can add in some little dots, single leaves or flowers.

6. Load a size 0 brush with some slightly diluted Bleedproof White and lightly tap the brush over the painting to create a star effect. Do not add too much water to the paint or your stars will end up too big. After the paint is dry, use a white pen to draw actual stars all around.

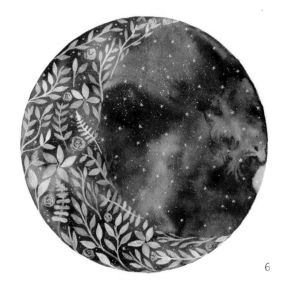

6

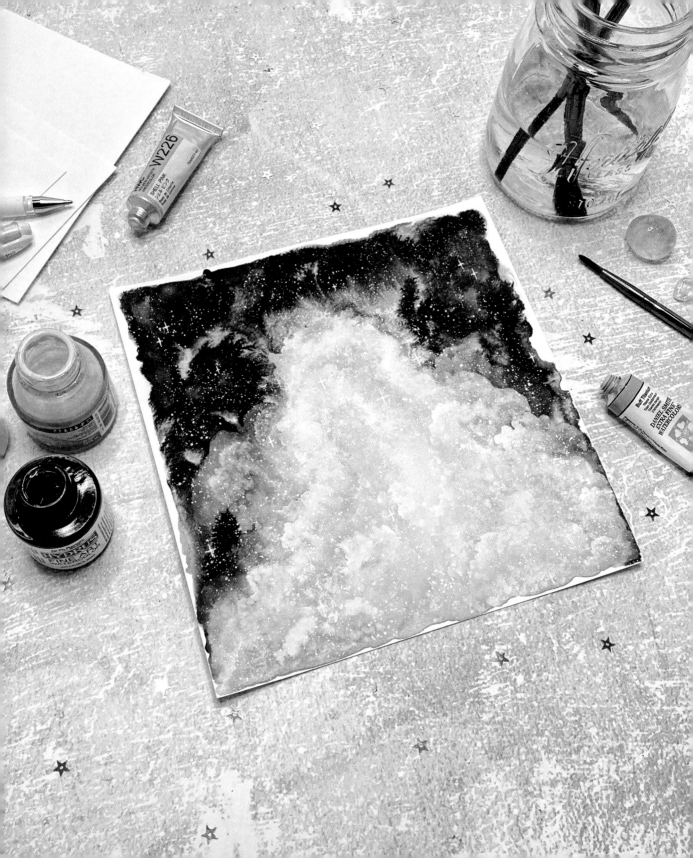

DREAMY WATERCOLOR SKIES

Dreamy, surreal skies are the foundation for almost all of my work. I typically start out creating a sky scene with a lovely mix of color and add details like clouds, stars, the moon, the sun and planets. There is no right or wrong way to interpret the heavens, and I find that painting them through an ethereal lens is both beautiful and calming. My favorite project in this chapter is Night Sky Shapes (page 48). I was inspired to paint it after seeing a lot of bullet journalers on social media create grids for keeping their lives organized. I decided to try organizing my imagination on a blank piece of watercolor paper in a similar fashion and paint lots of little separate pieces of the universe on one page. Dig deep into your imagination, and let's get started painting the universe above!

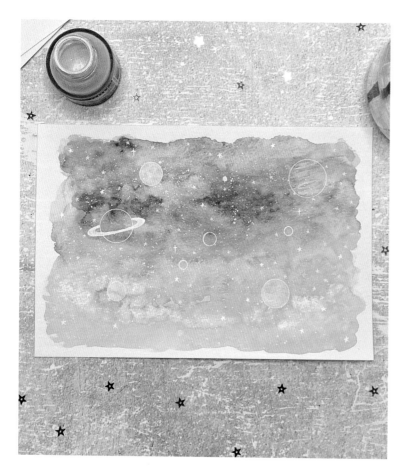

COSMIC BACKGROUND

Most of my art revolves around backgrounds like this one, with gorgeous blends of colors and some shimmer for a cosmic feel. I love these backgrounds because they are very versatile. You can display them in a frame, paint them in a journal or add them to stationery. They are pretty simple to create—all you need are some gorgeous color mixes, shimmer paint and your imagination!

Supplies

Paintbrushes, sizes 0 and 8

6 x 9" (15 x 23-cm) sheet watercolor paper

Circle maker or stencil tool

White pen (I used a Uni-Ball Signo Pen)

Metallic silver pen (I used a Pentel Sparkle Pop Pen)

Color Palette

 Daniel Smith Moonglow

 My Pink Mix (page 16)

 My Peach Mix (page 16)

 Daler-Rowney Aquafine Gold

 Dr. Ph. Martin's Bleedproof White

1. Use a size 8 brush to apply a wash of water over the entire sheet of paper. Get as close to the edge as you can without causing water to spill outside the edges of the paper.

2. While the paper is still wet, load your brush with Moonglow and brush it horizontally across the top third of the paper. Work quickly so the wash doesn't dry. Next, load your brush with My Pink Mix and apply it just below the Moonglow until you have covered another third of the paper. Encourage the bleeding and blending of the two colors by swirling your brush through the area where the two paint colors meet. Next, apply My Peach Mix to the bottom third of the paper. Encourage the Peach Mix and Pink Mix to blend together. Before these colors dry, dab a little Gold paint into the pink and peach colors for some added sparkle. Allow the paint to dry completely.

3. Once your background is dry, load a size 0 brush with some slightly diluted Bleedproof White and lightly tap the brush to create a star effect. Do not add too much water to the paint or your stars will end up too big. Once the white paint is dry, you can add in some hand-drawn stars with a white pen as well.

4. Use your circle maker or stencil tool to draw some basic circles with a white pen on the paper. The circle maker tool is great for this because it actually has seven circles inside of it that are the perfect sizes for the planets. There is no rhyme or reason to the way these circles are placed on the background—just place them around your background as you wish.

5. Next, add a little detail to the planets. Draw a ring around Saturn with a white pen. Using some diluted Bleedproof White, paint a couple of your planets to differentiate between them. Brush some lines representing clouds and the Great Red Spot in the circle you dedicated for Jupiter. Use the white pen to draw some stars across the background.

6. Once you are happy with your planets, you can add in a few final details with a metallic silver pen such as a shooting star, some other circles to represent moons and maybe a few more stars.

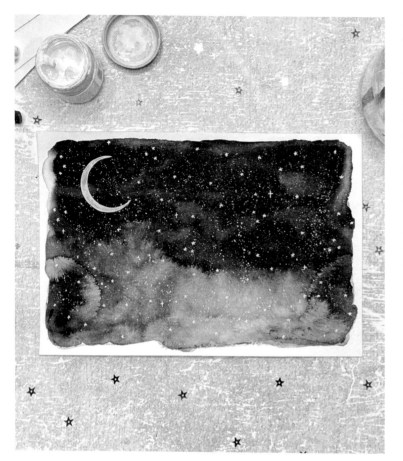

STARRY NIGHT

If you've never worked with sumi ink before, now is the time! It's an amazing medium that will take you to the cosmos! In this project you will be using some sumi ink to paint the night sky. I encourage you to test out some sumi ink on a scrap piece of paper before you begin to see how it interacts with water. A little bit goes a long way! I chose sumi ink for this project because it is a very black ink that is perfect for a starry night sky scene. Plus, just watching the ink swirl around in water can be very cathartic.

Supplies

Paintbrushes, sizes 0 and 8

6 x 9″ (15 x 23–cm) sheet watercolor paper

Circle maker tool

White pen (I used a Uni-Ball Signo Pen)

Color Palette

 Yasutomo Black Sumi Ink

 Dr. Ph. Martin's Bleedproof White

1. Use a size 8 brush to apply a wash of water over the entire sheet of paper. Get as close to the edge as you can without causing water to spill outside the edges of the paper.

2. While the paper is still wet, load your brush with sumi ink and brush it along the top edge of the wet paper. The idea is to create a gradient effect that is darker at the top and gets lighter in the bottom half of the page. Encourage the ink to bleed down your paper by brushing the ink across the page until the paper is completely covered with it. Let the paper dry thoroughly.

3. Once the background is completely dry, add some stars. Load a size 0 brush with some slightly diluted Bleedproof White and lightly tap the brush over your painting to create a star effect. Do not add too much water to the paint or your stars will end up too big.

4. After the stars are completely dry, use the 1½-inch (4-cm) circle on your marker tool and a white pen to sketch in a crescent moon at the top corner of the paper. Trace half of the 1½-inch (4-cm) circle on your piece of paper. Then slide the marker slightly to the right of the half circle you just drew. Trace the other half of your crescent with the white pen.

5. Load a size 0 brush with some diluted Bleedproof White and paint your crescent moon. After the moon is dry, add some actual star shapes all over the piece with a white pen. You now have a beautiful starry night to frame or use in an art project!

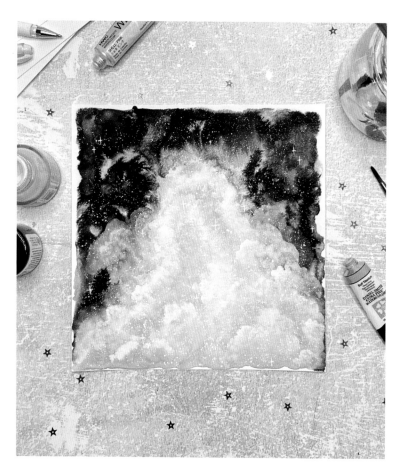

SPARKLING GALAXY NEBULA

I was inspired to create this project while camping in northern Michigan, along the lakeshore in the fall. When you go out into nature away from the light pollution, it's like the universe is right there above you. So many more stars are visible, and you can even see the Milky Way start to rise up out of the southern sky. I took a snapshot of this sky in my mind and wanted to keep the memory by painting what I saw. This project can be framed and used as wall art, or it can make a beautiful cosmic background in a journal.

Supplies

Paintbrushes, sizes 0, 6 and 8

8 x 8" (20 x 20–cm) sheet watercolor paper

White pen (I used a Uni-Ball Signo Pen)

Color Palette

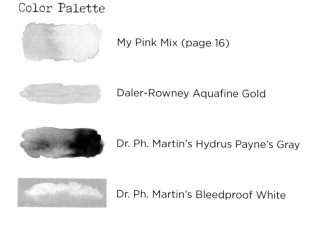

My Pink Mix (page 16)

Daler-Rowney Aquafine Gold

Dr. Ph. Martin's Hydrus Payne's Gray

Dr. Ph. Martin's Bleedproof White

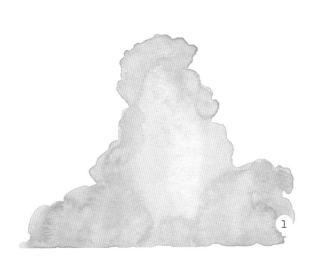

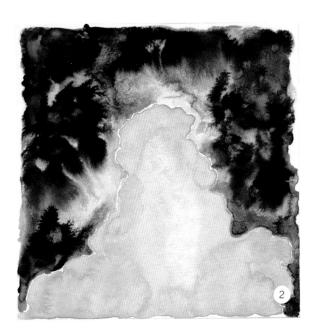

1. With a size 8 brush, use the wet-on-dry technique (page 13) to loosely apply My Pink Mix to the bottom three-quarters of the paper. There is no specific way for this to be done. Just let yourself be free with the brush and how you apply the paint. I created almost a triangle shape, but notice that the edges are organic and flowy. One of the easiest ways to do this is to just put down some paint on your paper and then add water to it, letting the water and paint bleed out a bit. Just be sure to leave some space on the page for the dark part of the nebula. While the pink paint is still wet, dab some Gold paint right down the center and let it spread out a bit.

2. Once the paper has dried completely, it's time to add the dark portion of the background. Start by applying a wash of water with a size 6 brush around where you put down the pink color. Be cautious not to get the pink part wet again because you don't want to activate the watercolor and have it mix with the gray. Load a size 6 brush with Payne's Gray and apply it to the wet portion of the paper. Get as close as possible to the pink parts without touching them with your brush. Also, be careful to avoid letting the watercolor spill over the edges of the paper. Let the paper dry completely.

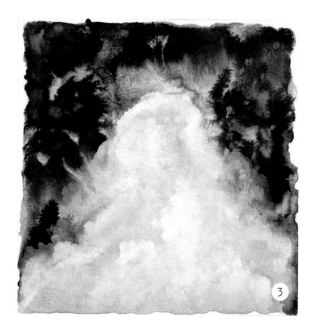

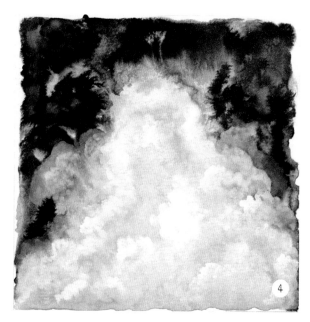

3. Next you will add some clouds in and around your nebula. Load your brush with some slightly diluted Bleedproof White. Start dabbing in little tufts of clouds all throughout the pink part of your nebula. A cloud is typically brighter at the top and slightly darker at the bottom. Just keep that in mind as you are creating your tufts of clouds. Start by applying the most white at the top of your cloud and then use water to blend it out toward the bottom. Continue adding clouds around the outer edges of your nebula so that they overlap the gray slightly.

4. The key to creating great clouds is layering, so continue refining your clouds by repeating Step 3. Layer in more diluted Bleedproof White on the tops of your clouds to create a nice gradient of white. If you get too much white in one area, just use some water to wash it out and blend it into the pink. Nebulas are cloudy and gaseous, so you want your nebula to have a haze of clouds.

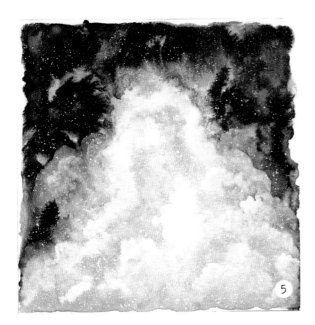 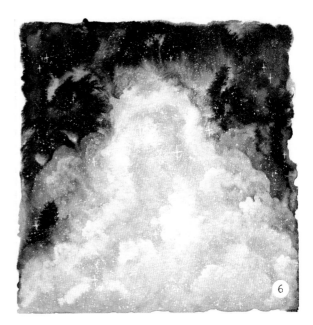

5. Once the clouds are dry, you are going to add some stars. Lots of stars! A nebula is like a nursery for stars, so there are millions of them! Load a size 0 brush with some slightly diluted Bleedproof White and lightly tap the brush over the painting to create a star effect. Do not add too much water to the paint or your stars will end up too big. Keep doing this all over the entire page until it is filled with a massive amount of stars!

6. For a finishing touch, use a white pen to create some shining stars that look like they have a burst of light coming from them. To do this, draw a dot or small circle on the page and then draw a cross or an X right through the circle. Randomly place ten to fifteen of these types of stars throughout the entire piece.

PERFECT SURREAL CLOUDS

Clouds are forever-changing works of art that are different every day. They're another one of nature's subjects that I love to paint. In this project you're going to make a dreamy sky full of clouds that look like tufts of cotton candy. With just a few colors, I'll show you how to make the perfect surreal clouds.

Supplies

Paintbrushes, sizes 0, 4, 6 and 8

6 x 9" (15 x 23–cm) sheet watercolor paper

Circle maker tool

Pencil and eraser

Metallic gold pen (I used a Sakura Gelly Roll Pen)

White pen (I used a Uni-Ball Signo Pen)

Color Palette

 My Teal Mix (page 16)

 My Pink Mix (page 16)

 Daler-Rowney Aquafine Gold

 Daniel Smith Moonglow

 Dr. Ph. Martin's Bleedproof White

1. Imagine a diagonal line that extends from slightly below the top left corner of your paper down to slightly above the bottom right corner. Use a size 8 brush to apply a wash of water to the top portion of your paper that is just above your imaginary diagonal line. While the paper is still wet, load a size 6 brush with My Teal Mix and apply it to the wet portion of the paper, working from the top of the page down to your imaginary diagonal line. Try to work quickly so the paper doesn't dry. Next, use a size 8 brush to apply a wash of water below the imaginary diagonal line down to the bottom of the page. Load a size 6 brush with My Pink Mix to apply to the newly wet portion of the paper. Start at the very top of the imaginary diagonal line and then brush the pink into the teal like you are connecting two pools of watercolor and let them bleed into one another.

Continue painting the pink down to the bottom of the page. While everything is still wet, dab some Gold paint into the teal part of the sky for some added shimmer, but do this sparingly. Then randomly dab some Moonglow into the pink. Let the paper dry completely.

2. Next, add some clouds to the bottom pink portion of your piece. Load a size 4 brush with some slightly diluted Bleedproof White. Start dabbing in little tufts of clouds all through the pink portion of your piece. A cloud is typically brighter at the top and slightly darker at the bottom. Just keep that in mind as you are creating your tufts of clouds. Start by applying the most white at the top of your cloud and then use water to blend it out toward the bottom.

3. The key to creating great clouds is layering, so continue refining your clouds by repeating Step 2. Layer in more diluted Bleedproof White on the tops of your clouds to create a nice gradient of white. If you get too much white in one area, just use some water to wash it out and blend it into the pink. Expand your clouds into the teal portion of the background by creating stand-alone clouds. Randomly add a few clouds throughout the teal, but don't get too crazy—just a few will do!

4. After the clouds have dried completely and you are happy with them, it's time to add a moon! Use the 1½-inch (4-cm) circle on your marker tool and a pencil to sketch in a crescent moon at the top right corner of the paper. Trace half of the 1½-inch (4-cm) circle on your piece of paper. Then slide the stencil slightly to the right of the half circle you just drew. Trace the other half of your crescent with the pencil. Next, load a size 4 brush with Gold paint and fill in the crescent moon you just drew.

5. Once the moon is dry, use a metallic gold pen to trace around it. Use the 1¾-inch (4.5-cm) circle on your stencil tool to draw a circle around the crescent with the same metallic gold pen. Then draw lines coming out from all around the circle to create moon beams with your metallic gold pen.

6. Finally, draw some stars with a white pen in the teal sky portion of your piece. Then, for a final starry effect, load a size 0 brush with some Gold paint and tap it all over your paper in a flecking manner to create some sparkle.

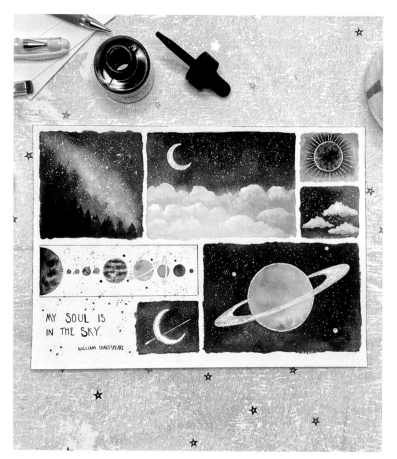

NIGHT SKY SHAPES

There is something spatially satisfying about mapping out your paper in a series of coordinating shapes and then painting something different in each one. It's like a surprise in each box! I started painting these shapes in my journals, and it was fun to paint more than one scene on one piece of paper. They are like bite-sized pieces of art on the same page. It's candy for your eyes!

Supplies

Ruler

Pencil and eraser

7 x 10" (18 x 25-cm) sheet watercolor paper

Circle maker tool

Circle stencil tool

Paintbrushes, sizes 0, 4 and 6

White pen (I used a Uni-Ball Signo Pen)

Metallic silver pen (I used a Pentel Sparkle Pop Pen)

Fine tip blue pen (I used a Pilot G-Tec-C4 Pen)

Color Palette

 Dr. Ph. Martin's Hydrus Payne's Gray

 Dr. Ph. Martin's Bleedproof White

 Daniel Smith Iridescent Moonstone

1: 3" x 3" (8 cm x 8 cm)

2: 4.5" x 3" (11 cm x 8 cm)

3: 1.75" x 1.25" (4 cm x 3 cm)

4: 1.75" x 1.25" (4 cm x 3 cm)

5: 4.75" x 1.5" (12 cm x 4 cm)

6: 4.75" x 3.25" (12 cm x 8 cm)

7: 1.75" x 1.5" (4 cm x 4 cm)

1

1. Use a ruler to draw a ¼-inch (6-mm) border around the entire piece of paper. Begin creating the boxes according to the following measurements. Work from left to right, top to bottom, as numbered, and keep about a ¼ inch (6 mm) of space in between all of the boxes. If your spacing or your measurements for each box are slightly off, that is okay—just try to keep your boxes as evenly spaced and as close to these sizes as possible.

1: For the first box, lightly draw a 3 x 3-inch (8 x 8-cm) square that is aligned with the top left corner of the border.

2: For the second box, measure ¼ inch (6 mm) to the right of the first box. Then draw a 4½ x 3-inch (11 x 8-cm) rectangle. The top of the rectangle should overlap the top border line you drew.

3 and 4: Measure over another ¼ inch (6 mm) to the right of box 2 and draw the third and fourth boxes. Measure a 1¾ x 1¼-inch (4.5 x 3-cm) rectangle so

that the right side of the rectangle will overlap with the right edge border, and so the top side of the rectangle will overlap the border at the top. Measure ¼ inch (6 mm) from the bottom of the third box and draw another box with the same dimensions.

5: Measure another ¼ inch (6 mm) down from the first row of boxes and draw a light line across the width of the paper. Using that line as a guide for the top of the fifth box, draw a 4¾ x 1½-inch (12 x 4-cm) rectangle that is aligned to the left border.

6: Measure another ¼ inch (6 mm) to the right of the fifth box, then lightly draw a 4¾ x 3¼-inch (12 x 8-cm) rectangle that is aligned to the right edge border. Erase the portion of the top border line in between the fifth and sixth boxes.

7: For the last box, measure ¼ inch (6 mm) down from the fifth box and to the left of the sixth box, then lightly draw a 1¾ x 1½-inch (4.5 x 3-cm) rectangle.

2a

2. Next, sketch in the celestial elements in their respective boxes (2a). Boxes 1, 2 and 4 do not require any sketching in this step. In box 3, use a circle maker tool to draw a ⅞-inch (2-cm) circle directly in the middle for the sun.

In box 5, using the 1⅜-inch (3.5-cm) circle on a circle stencil tool, draw a half circle for the sun on the left side of the box. Then use the stencil's other circle sizes to create the nine planets, with Jupiter as the largest circle and Pluto as the smallest.

Directly in the middle of box 6, draw a 2-inch (5-cm) circle with the circle stencil tool for Saturn. Lastly, draw a crescent moon in box 7 using a circle maker tool.

We will paint the backgrounds for all of the boxes in a monochromatic color scheme just using values of Payne's Gray by adding more or less water (2b). Unlike a wash, you will put down the watercolor directly on the paper and then load the brush with additional water to spread around the watercolor. This is the wet-on-dry method (page 13).

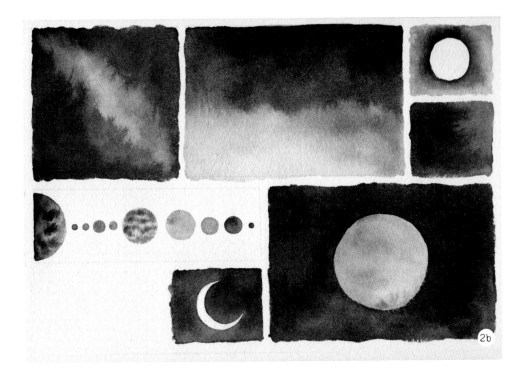

Begin painting in box 1 with a size 6 brush by laying down the most color around the edges and washing it out with water as you approach the middle of the box, working diagonally from the top left corner to the bottom right. The goal is to create the appearance of a galaxy going across the sky at a diagonal.

For box 2, you'll create the background for a night sky scene where the moon will be painted at the top and clouds at the bottom. Begin by laying down the most color across the very top of the square and wash it out with water toward the bottom so that the color gets lighter as it approaches the bottom of the square.

In box 3, use a size 4 brush to paint around the circle you drew. Start by adding the most color directly around the circle and then washing it out with water toward the edges of the rectangle.

Paint box 4 completely by adding the most color along the left edge of the rectangle and using a little water to spread the paint out across the remainder of the rectangle.

In box 5, paint the circles you made for the planets, making some of them lighter and some darker for contrast. For example, paint Saturn lighter and paint Jupiter with lines of dark and light color by varying the amount of water used to dilute the paint.

In box 6, paint the circle for Saturn with a diluted Payne's Gray. Then using the most color, paint the background around Saturn using very little water to move the color, covering the entire rectangle.

For box 7, using the most color and little water, paint the background of the crescent moon. Let all of the boxes dry thoroughly.

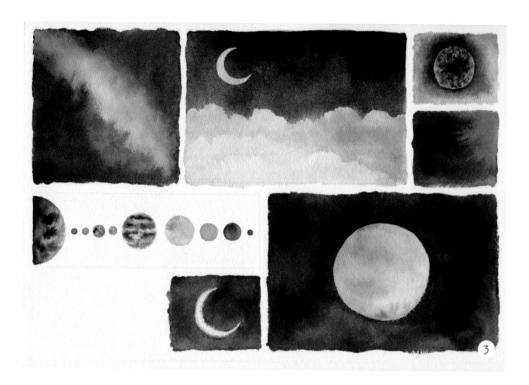

3. In box 1, refine the galaxy by washing in some diluted Bleedproof White in the middle of the galaxy, working diagonally from the top left to the bottom right of the square. Keep the middle of the galaxy saturated with white and then use some more water on your brush to wash it out as it approaches the Payne's Gray.

Create a crescent moon in box 2 at the top left using the circle maker tool and a pencil. Then load a size 0 brush with Iridescent Moonstone and paint the moon. Dab some clouds under the moon at the bottom of the rectangle with Bleedproof White, just as in the Perfect Surreal Clouds project (see page 44). Keep the white positioned at the top of your clouds and use more water on the brush to wash them out toward the bottom of the cloud.

In box 3, use a size 4 brush to paint the sun with Payne's Gray. Lay down some water in your circle first and then dab some paint throughout the circle to give it a little variation. If you spill the paint outside of the circle, just go in with a little more watercolor to darken the background just behind the circle to cover up any paint leaks.

In box 5, refine some of your planets a little more by adding in an additional layer of watercolor. Adjust the color by diluting the Payne's Gray so that you are keeping the color variations in the planets as you add another layer. Give Jupiter some refined stripes with a size 0 brush by adding varied dilutions of Payne's Gray. To give Jupiter a few swirls, brush a few stripes of the Bleedproof White through the Payne's Gray.

In box 7, use a size 0 brush to paint the crescent moon just as you did in box 2 with Iridescent Moonstone. Let everything dry completely.

4. Define some of the clouds in box 2 by adding a little more Bleedproof White to the tops of the clouds with a size 0 brush and blend out the white with water toward the bottom of the cloud.

In box 4, use a size 4 brush to paint three staggered clouds at the bottom with Bleedproof White. Just as you've painted clouds previously, keep the tops saturated with the white and blend them out with water toward the bottom.

In boxes 1, 2, 4, 6 and 7, add white stars by loading a size 0 brush with some slightly diluted Bleedproof White and tapping the brush over these five squares.

Use paper scraps to cover the solar system in box 5, Saturn in box 6 and the sun in box 4 so that you don't add stars to these. If you accidentally get stars on an area you didn't intend to, just get a clean brush slightly wet, brush it across the splotch of white and dab it up with a paper towel.

In box 5, add in some gray stars by loading a size 0 brush with some slightly diluted Payne's Gray and tapping it over the box to create the appearance of a solar system. Cover box 2 with a piece of scrap paper so you don't get gray stars in your white clouds. If the stars spill over the box, it's okay—it adds a nice effect.

5. In box 1, paint a tree line at the bottom of the galaxy by loading a size 0 brush with Payne's Gray and a little bit of water. The trees don't have to be perfect, so don't overthink them! Start out with a triangle at the top for the treetop and paint a line straight down to the bottom of the square. Then, from the bottom of the triangle all the way down the line, make brushstrokes back and forth across the line, angling down slightly. Add more watercolor to darken the tree as needed. Add in a few sparkling stars in the galaxy by drawing dots and marking an X or a cross through them with a white pen. Then add a few more dots of sparkle throughout the sky with a metallic silver pen.

In box 2, with the metallic silver pen, outline the crescent moon.

In box 3, with the same pen, outline the sun and draw rays extending out all around it. You can freehand these rays.

In box 4, add a few dots of sparkle throughout the sky again with the metallic pen, as you did in box 1.

In box 5, use the metallic silver pen to draw Uranus and Saturn's rings, along with a tiny crescent moon above Earth.

In box 6, with a size 0 brush, paint Saturn's rings with Iridescent Moonstone. Then use a white pen to draw three small circles around Saturn and color them in to represent a few of Saturn's largest moons. Use the metallic silver pen to trace around Saturn, being careful not to cross the rings you just painted.

In box 7, trace around the crescent moon with the metallic silver pen and then add a shooting star going right behind the crescent moon. Draw a small sideways teardrop shape for the star and a line extending out from the teardrop shape for the star's tail.

6. Lastly, use the metallic silver pen to add some more dots of sparkle to each scene randomly (6a). Use a fine tip blue pen to trace over your pencil lines around box 5 with the solar system. With the same pen, write a quote in the blank space just below box 5 with the solar system and to the left of box 7 with the crescent moon. Feel free to use this quote by Shakespeare: "My soul is in the sky" (6b). Or use a different quote of your own if you choose. For a finishing touch, add a little more star love by using the same blue pen to make little stars around the quote.

COSMIC SNAPSHOTS

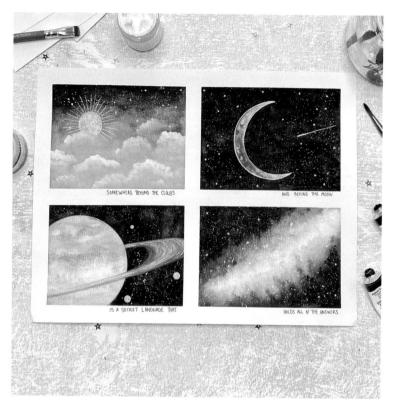

This is my favorite project in the whole book. There is something magical about it—the way the colors mix and blend together, and the words that complement each scene. The Mayan Dark Blue used in the background is truly cosmic. As in Night Sky Shapes (page 48), you are going to paint stellar scenes inside four evenly spaced rectangles. It feels organized and turns out beautifully. Maybe that is why it is so satisfying!

Supplies

½" (1.3-cm)-wide washi tape

9 x 12" (23 x 30.5–cm) sheet watercolor paper

Ruler

Paintbrushes, sizes 0, 4 and 6

Circle stencil tool

Pencil and eraser

Circle maker tool

White pen (I used a Uni-Ball Signo Pen)

Metallic gold pen (I used a Sakura Gelly Roll Pen)

Warm gray pen (I used a Sakura Gelly Roll Moonlight Pen)

Color Palette

 Daniel Smith Mayan Dark Blue

 My Teal Mix (page 16)

 My Vanilla Mix (page 16)

 Daler-Rowney Aquafine Gold

 Dr. Ph. Martin's Bleedproof White

 My Pink Mix (page 16)

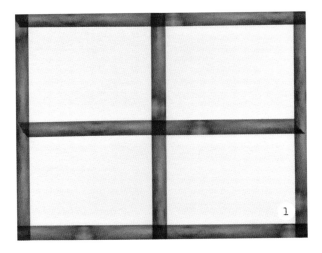

1. Use washi tape to create a grid on your watercolor paper. First, tape along the edges of the paper and then apply two more strips of washi tape to divide the paper into four equal, evenly spaced boxes that measure approximately 5¼ x 3½ inches (13 x 9 cm).

2. In box 1, use Mayan Dark Blue and My Teal Mix to paint the daytime sky scene. Load a size 6 brush with water and brush it across the first square. Then load it with Mayan Dark Blue and brush it across the top portion of your sky. Apply some of My Teal Mix across the sky just underneath the Mayan Dark Blue. Let the two colors bleed into one another and add a little water where they meet to encourage blending. Add more Teal Mix all the way down to the bottom of the square.

In box 2, paint the night sky scene. Apply a wash of water to the square and then paint across the entire box with Mayan Dark Blue. You want this box to be really dark blue, so the more color you have loaded on your brush, the better.

In box 3, with a circle stencil tool, draw a circle that is cut off at the bottom left of the square. I made a 3½-inch (9-cm) circle. This will be Saturn. Apply a little wash of water around Saturn and then add Mayan Dark Blue until the background is filled in.

In box 4, paint a galaxy by applying a light wash of water at the top left corner of the box as well as the bottom right corner. With a size 6 brush, apply Mayan Dark Blue at each corner, making sure to saturate both areas well with a lot of the blue. Then load your brush with My Teal Mix and brush it diagonally across the box, just along the edge of the Mayan Dark Blue. Add a little water to let the two colors bleed into one another. Do this on both sides of the Mayan Dark Blue you added to each corner. Encourage the teal to bleed into the middle of the square with a bit of water. Then you're going to disrupt the middle of the teal with a stroke of My Vanilla Mix right down the center. While everything is still wet, load your brush with Gold paint and apply it right over the Vanilla Mix. The colors will interact, interrupt each other and swirl around. You can encourage the colors to bleed into one another by adding a little dab of water here and there. Let the square dry completely.

3. Next, you're going to add stars to all four squares by loading a size 0 brush with some slightly diluted Bleedproof White and lightly tapping the brush over your painting to create a star effect. Do not add too much water to the paint or your stars will end up too big. Then you are going to fill in Saturn in box 3 with My Teal Mix, Pink Mix, Vanilla Mix and some Gold paint. Start by loading your size 6 brush with some Teal Mix and apply it across the middle of Saturn. Load your brush with some Vanilla Mix and apply it just next to the Teal Mix. Add a little extra water and let them bleed into one another. Then dab some Pink Mix next to the vanilla, letting those two colors bleed into one another. Continue this pattern until your Saturn is painted. Let the paper dry completely.

4. Add in some details in all the squares. In box 1, use a size 4 brush to start dabbing in tufts of clouds in the teal portion of the box with Bleedproof White, making the tops of the clouds whiter and washing them out toward the bottom of the cloud. Freehand paint a sun peeking out from behind one of the clouds with Gold paint. In box 2, use a 2¼-inch (6-cm)-sized circle on a circle stencil tool to draw a crescent moon. Dilute some Bleedproof White and paint inside the crescent moon. The white will mix slightly with the blue of the sky and make a light blue color. Dab a bit of the Gold paint randomly throughout the crescent. Next, paint Saturn's rings using the same technique: Dilute some Bleedproof White and paint the rings with a size 4 brush, mixing the white slightly with the blue to create light blue rings. Again, dab some Gold paint throughout the rings.

5. Add some finishing touches with a white pen and a metallic gold pen. Begin by adding some white stars in the top part of your sky in box 1. Add some white stars to the sky in box 2 and box 4, as well. Then use the metallic gold pen to outline the sun in box 1, but don't make a complete circle, because you want the sun to look like it's just behind the cloud. Use a ruler to draw rays extending out from the sun. In box 2, use the gold pen to trace around the crescent moon and then create a shooting star that looks like it's heading for the moon. To create an easy shooting star, draw a very small oval shape and then draw one to three lines extending out from the oval shape like the tail of a shooting star. In box 3, use a circle maker tool to create three of Saturn's largest moons just outside its rings. Make two large moons in the foreground and one small one in the background. Using the metallic gold pen, trace around Saturn and add some defining lines around Saturn's rings, but remember not to go through the rings. In box 4, dot some stars with the metallic gold pen all throughout the middle of the galaxy. Then create a few shining stars in the galaxy as well. To make the shining stars, make a dot with the gold pen and then draw a cross or an X through the center.

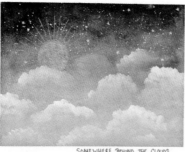

SOMEWHERE BEYOND THE CLOUDS

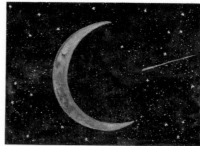

AND BEHIND THE MOON

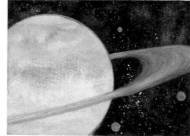

IS A SECRET LANGUAGE THAT

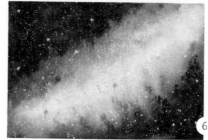

HOLDS ALL OF THE ANSWERS

6. Lastly, carefully pull off the washi tape from around the boxes. You should have four cleanly defined boxes, but if you find some of the watercolor leaked under the washi tape, apply some water to those areas with a clean brush and use a paper towel to dab up the water and remove the paint. For an added touch, add a quote to your piece, such as

"Somewhere beyond the clouds and behind the moon is a secret language that holds all of the answers." Divide the quote into four sections and use a warm gray pen to write it. Under box 1, write the words "Somewhere beyond the clouds." Under box 2, write "and behind the moon." Under box 3, write "is a secret language that," and under box 4, write "holds all of the answers."

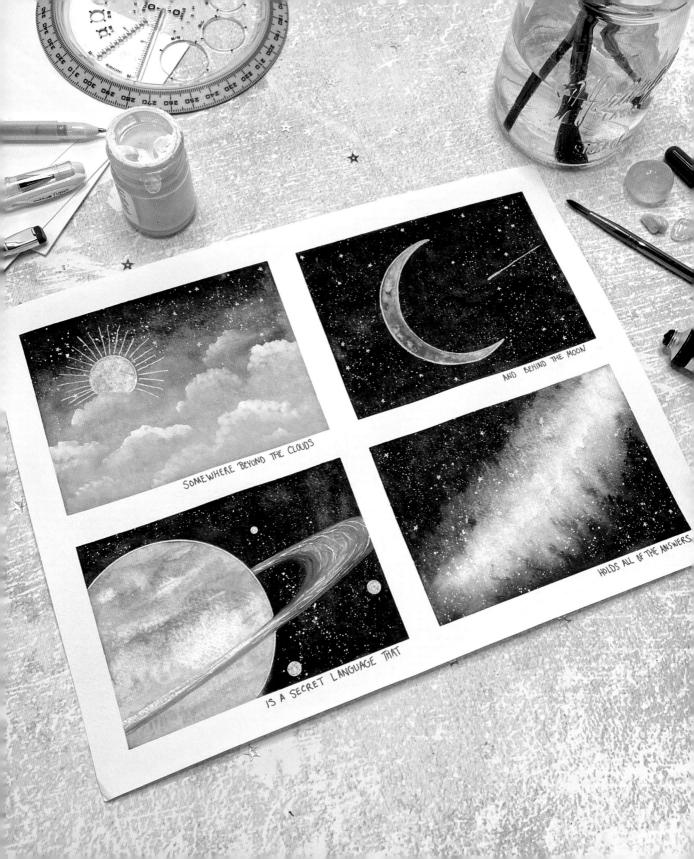

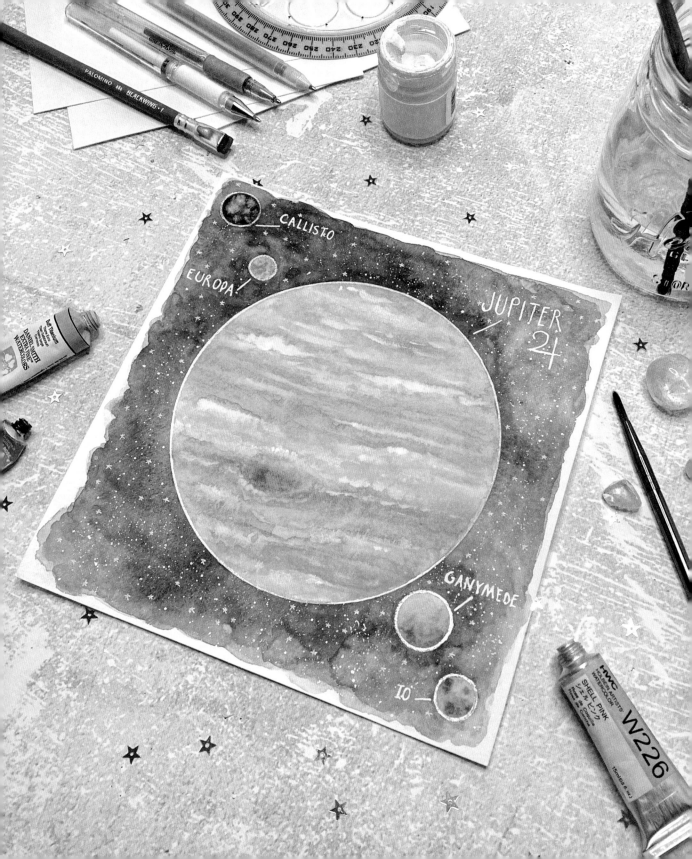

PAINTING THE PLANETS

I'm awestruck by astronomy and the science that is continually exploring our existence. Our solar system is full of majestic and breathtaking planets that make beautiful artistic subjects. Saturn and Jupiter are among my favorites for obvious reasons! Not only are they the biggest planets, but they also have the most beautiful details. Watercolor is a great medium for capturing cosmic landscapes because it makes it effortless to achieve colors that blend and flow together.

My favorite project in this chapter is Jupiter and the Galilean Moons (page 69) because it meshes art with science. I was inspired to create this project after gazing through my telescope at Jupiter and Saturn in my backyard during the summer. They were the closest they'd been to the earth in 20 years, and I could see both of them through my telescope. One night I stood in awe for several hours, squinting my left eye and adjusting my telescope so that I could keep taking in the moment. I knew I had to document what I saw through my scope in my journal, and that's when I painted a diagram of Jupiter.

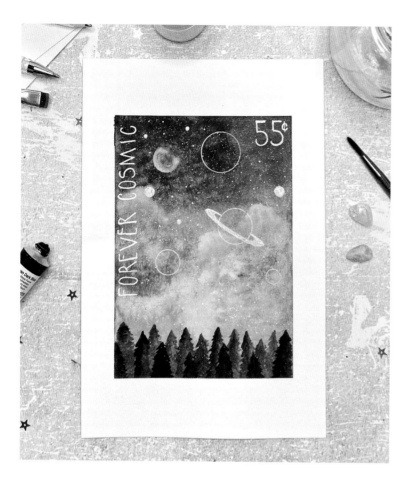

POSTAGE STAMP

Postage stamps can be nostalgic and fun to collect, but they are also art forms of the times. I was inspired to create this project as a reminder of how painting the cosmos has been such an important part of my life as of late. It's been a time of creative and spiritual growth for me as an artist. This project would make a nice framed piece of art so that you, too, can remember this time in your life.

Supplies

¾″ (2-cm)-wide washi tape

6 x 9″ (15 x 23–cm) sheet watercolor paper

Ruler

Paintbrushes, sizes 0, 6 and 8

Metallic gold pen (I used a Sakura Gelly Roll Pen)

Circle maker tool

Pencil and eraser

White pen (I used a Uni-Ball Signo Pen)

Color Palette

 Daniel Smith Mayan Dark Blue

 Daniel Smith Mayan Blue Genuine

 My Teal Mix (page 16)

 Dr. Ph. Martin's Bleedproof White

 Grumbacher Academy Charcoal Gray

1. Apply washi tape around the entire outer edge of your paper. Then double up the washi border on the top and bottom of your paper with a second piece of washi positioned just underneath the first piece. This will create a 1½-inch (4-cm) border just on the top and bottom of the stamp. Now your stamp will be about 4½ x 6¼ inches (11 x 16 cm) in size.

2. Next, load a size 8 brush with water and apply a wash of water to the entire page. You'll want to make sure you get your working area wet, but not the washi tape. Load the same brush with Mayan Dark Blue and apply it to the top third of your stamp. Then apply Mayan Blue Genuine just below the dark blue and let the two colors blend and bleed together. Working quickly while the paper is still wet, load your brush with My Teal Mix and apply it just below the Mayan Blue Genuine and down the remainder of the page. If needed, you can use additional water to encourage the colors to blend together. Dab more color where you need it so that the entire page is painted. The idea is to have the sky start with the darker blue at the top and then blend down to a lighter teal color toward the bottom. Let the paper dry completely.

3. Next, you will add in some stars. Load a size 0 brush with some slightly diluted Bleedproof White and lightly tap the brush over your painting, creating a star effect. Do not add too much water to the paint or your stars will end up too big. Add stars to your entire piece and then let the painting dry.

4. Now create a tree line at the very bottom of the stamp. Start with some slightly diluted Charcoal Gray. Use a size 0 brush to paint some background trees that will be slightly lighter than the rest. Start each tree with a triangle at the top and a line straight down to the bottom of your stamp. Working from the bottom of the triangle all the way down the tree, make brushstrokes back and forth across the line, angling down slightly. Let the background trees dry, then use a less diluted mixture of Charcoal Gray to add in some darker trees in the foreground, giving the tree line some depth. Paint the second line of trees in between your first line of trees to fill it in. After you are happy with your trees and everything is dry, carefully peel off the washi tape.

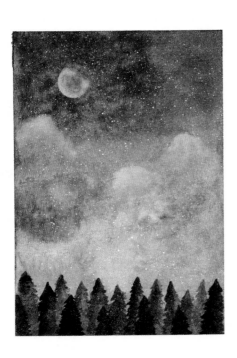

5

6

5. Next, paint a couple of light clouds and a three-quarter moon in the background. Load a size 6 brush with Bleedproof White and dab a few sparse cloud tufts toward the top of the paper, about where the Mayan Dark Blue meets the Teal Mix on your background. Then freehand paint a three-quarter moon in the top left corner of your stamp. Use the Bleedproof White and a size 0 brush to paint a half circle, then load your brush with a little water and blend out the white into the background so it looks like the moon is peeking out of the sky.

6. Use a metallic gold pen and a circle maker tool to draw nine planets in the sky of your stamp. Vary the planets by filling in some of the circles with the gold pen and leaving others just as an outline. Draw Saturn's rings with the gold pen and then add some smaller dots around the planets to represent moons. Lastly, dot your background with the gold pen throughout the sky to create some sparkle.

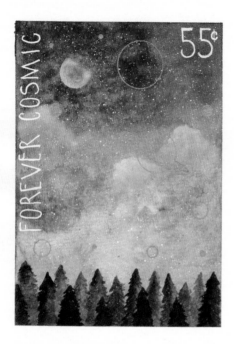

7

7. For the finishing touch, to make this piece look like a stamp, add a phrase down the left side and then add a price in the upper right corner to show how much your stamp costs. Write "FOREVER COSMIC" along the left side of the stamp, starting just above the tree line. Use a white pen to freehand the letters. You can always write them out lightly with a pencil first so you can space them out nicely and then go over your pencil lines with the white pen. Finally, in the top right corner of your stamp write "55¢" with the white pen. As with the letters, it's okay to freehand the numbers. Clean up any edges if needed by adding a little water to areas of paint that might have spilled out under the edges of the washi tape and dab it up with a paper towel.

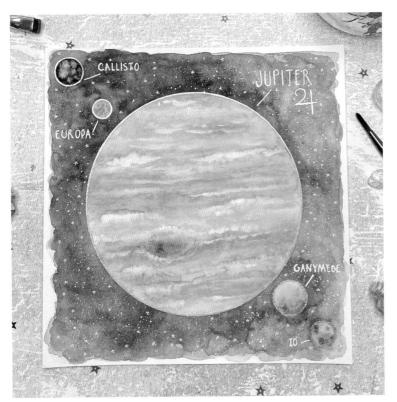

JUPITER AND THE GALILEAN MOONS

Planets are magical and mysterious. I think that is why they make it into a lot of what I create. Each one has so many features and unique characteristics. For example, Jupiter has 79 moons, and only 53 of them have official names. Doesn't that blow your mind? Jupiter's four largest moons—also called the Galilean moons—rival the size of small planets. I thought it would be a fun project to paint Jupiter with these four moons in a really illustrative way with a scientific twist. While you are doing this project, it might be helpful to reference images of the Galilean moons.

Supplies

8 x 8" (20 x 20–cm) sheet watercolor paper

Ruler

Pencil and eraser

6" (15-cm) circle maker tool

Paintbrushes, sizes 0, 4, 6 and 8

White pen (I used a Uni-Ball Signo Pen)

Metallic silver pen (I used a Pentel Sparkle Pop Pen)

Metallic gold pen (I used a Sakura Gelly Roll Pen)

Color Palette

 My Pink Mix (page 16)

 My Peach Mix (page 16)

 My Vanilla Mix (page 16)

 Daniel Smith Bordeaux

 Daniel Smith Moonglow

(continued)

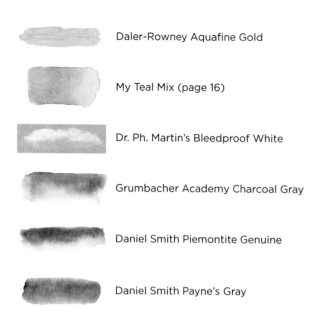

Daler-Rowney Aquafine Gold

My Teal Mix (page 16)

Dr. Ph. Martin's Bleedproof White

Grumbacher Academy Charcoal Gray

Daniel Smith Piemontite Genuine

Daniel Smith Payne's Gray

1

1. Find the middle of your paper by measuring half the length on each side and lightly drawing a horizontal line. Then measure half the width on each side and lightly draw a vertical line across the page. Where the lines connect is the center of the paper. Use the guidelines to draw a 6-inch (15-cm) circle in the middle of your paper with a circle maker tool, then erase the guidelines. Next, use four different circle sizes within your circle maker to create Jupiter's moons. Imagine a diagonal line running from the top left corner to the bottom right corner of your paper and draw two moons on the top left and two moons on the bottom right.

2. To paint Jupiter, load a size 8 brush with water and apply a wash of water to the 6-inch (15-cm) circle, being careful not to let any water spill outside the circle. Then load a size 6 brush with My Pink Mix and apply bands of color across the width of Jupiter, leaving space in between the bands. Next, apply bands of My Peach Mix just under the bands of Pink Mix. Then apply bands of My Vanilla Mix under the bands of Peach Mix until Jupiter is filled in. While your paint is still wet, apply a light wash of Bordeaux in a band across the bottom third of your Jupiter and an oval shape on the left side of the middle band. Let the paper dry.

2

3

4

3. Next, you are going to paint Jupiter's moons. Keep in mind that we are striving for a more illustrative idea of what they look like rather than an exact replication, so don't overthink these! Callisto is a dark-colored moon with spots all over it. Load a size 4 brush with Moonglow and paint Callisto. Then dab on some spots of Gold paint. You will notice that the gold interferes with the Moonglow nicely, leaving spots.

For Europa, which is light blue with some orangey-red bands through it, use the same size 4 brush to fill it in with My Teal Mix. Then load some Bordeaux on the size 4 brush and brush it throughout the teal to create lines or splotches of color.

Ganymede is the largest moon and looks similar in color to our moon. It's a grayish blue color with darker areas. Mix a light gray-blue color by combining My Teal Mix with some Bleedproof White and a dot of Charcoal Gray. Dilute the color with water and brush it in your Ganymede circle. While the paint is still wet, dab some Moonglow at the very bottom to create a little bit of a shadow.

Lastly, paint Io, which is the second smallest moon. It is an orangey color with darker spots throughout. Load a size 4 brush with My Peach Mix to paint Io. Then add a dab of Piemontite Genuine to the Peach Mix to create dark spots. Let everything dry completely.

4. Combine Charcoal Gray and a few dabs of Payne's Gray to create a cool gray. Dilute it slightly with a little water. Load your brush with water and carefully apply a water wash to the background around Jupiter and the moons, getting your paper slightly wet but being careful not to cause water to spill over the edges. Apply the cool gray mix all throughout the background. Let it dry completely.

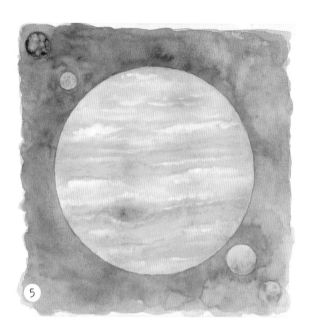

5. Add another layer of paint to Jupiter to darken the bands a little. Use the same colors as in Step 2 and let them blend and bleed into one another. While the paint is still wet, apply Gold paint to the fresh bands of Vanilla Mix. Let it bleed and interrupt the other colors. Also darken up your Great Red Spot and the reddish band across Jupiter with more Bordeaux. While things are still wet or semi-wet, dab some Bleedproof White on some bands. The white will blend into the colors and resemble clouds. Define the Great Red Spot with more white clouds.

After Jupiter has dried completely, add in another layer of the cool gray mix to your background using the wet-on-dry technique (page 13), being careful not to paint over your moons and Jupiter.

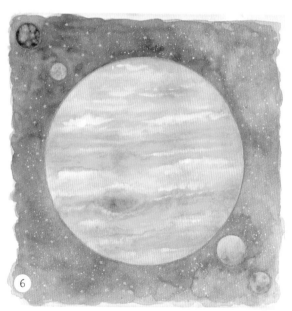

6. Load a size 0 brush with slightly diluted Bleedproof White and lightly tap the brush over your painting, creating a star effect. Do not add too much water to the paint or your stars will end up too big. You'll want to cover Jupiter and your moons with a piece of scrap paper or a paper towel while you add in stars so the paint only falls on the background. Let it dry. Then use a white pen to hand-draw some stars all throughout the background. Next, trace around your moons with a metallic silver pen and your circle maker tool. Then use a metallic gold pen to trace around Jupiter.

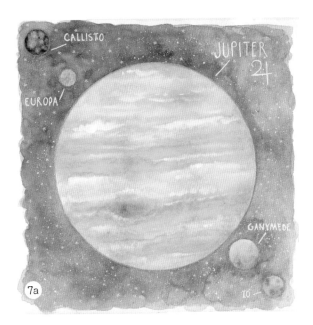

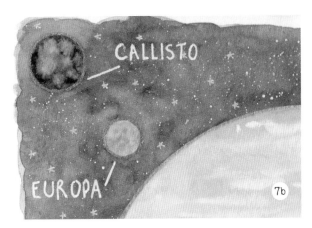

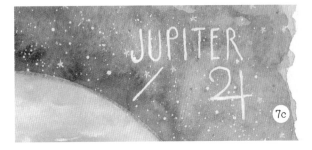

7. Finally, for an added scientific touch, label the moons and Jupiter (7a) and (7b). With a white pen, write "Jupiter" in the upper right corner of your piece and draw a line extending to the painted planet (7c). You can also add in the symbol for Jupiter, which looks like a fancy 4 (7c). Label the moons in the same way (7d).

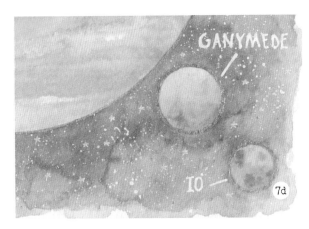

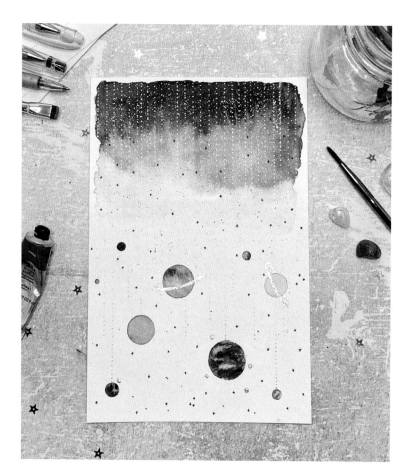

HANGING PLANETS

It's fun to reinvent how things look or how they actually are. It's part of using your imagination or, as I like to describe it, being a creative soul. This project reimagines what planets look like in space. In reality, they are in orbit, floating along, but what if they were hanging from chains of stars? Wouldn't that be beautiful? That's what you will find out in this project!

Supplies

Paintbrushes, sizes 0, 4 and 8

6 x 9″ (15 x 23-cm) sheet watercolor paper

Pencil and eraser

Circle maker tool

Ruler

Metallic silver pen (I used a Pentel Sparkle Pop Pen)

Fine tip blue pen (I used a Pilot G-Tec-C4 Pen)

Color Palette

 Winsor & Newton Indigo

 Dr. Ph. Martin's Bleedproof White

1.

1. Start by loading a size 8 brush with water and apply a wash loosely across the top third of your paper. You want the water to flow uncontrolled across the paper so it looks like a large cloud that is moving in from the top of your paper. Load your size 8 brush with Indigo and apply it to the wash area, starting at the very top of the paper. This color bleeds amazingly through the water naturally. You can move the color around in the water or add more blue in spots, but you want the color to bleed downward and get lighter as it reaches the bottom of the wash area on the paper. Let the paper dry thoroughly.

2. Using your circle maker tool, draw nine circles beneath the Indigo section to represent the nine planets. Use the various circle sizes on your circle maker tool to represent the sizes of the planets accordingly. For example, use the largest circle for Jupiter and the smallest for Pluto. Randomly place your circles but evenly space them on the bottom two-thirds of your paper.

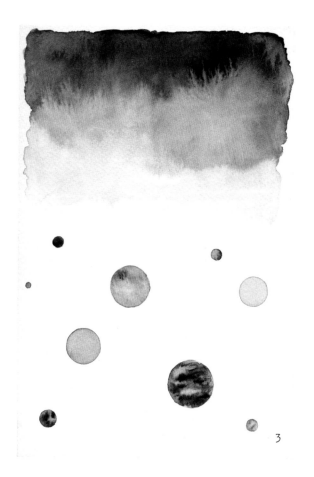

3. Use a size 4 brush to fill in all nine planets with Indigo. Vary the concentration of the color to give the planets some contrast. You can do this by just adding more paint for a darker color or more water for a lighter color. Add lines of light and dark blue across Jupiter. Let your planets dry completely.

4. In the upper blue portion of your paper, add some white stars by loading a size 0 brush with some slightly diluted Bleedproof White. Lightly tap the brush above your painting, creating a star effect. Do not add too much water to the paint or your stars will end up too big. Then load your size 0 brush with some slightly diluted Indigo and do the same thing across the bottom two-thirds of your paper to make blue stars. Don't worry about getting the blue specks on your planets.

5. Use a metallic silver pen to draw Saturn's and Uranus's rings. Add in some of Saturn's and Jupiter's biggest moons with the same pen by drawing little circles right next to the planets. You can use your circle maker tool to draw these. Add a crescent moon next to your Earth and a few smaller moons around Uranus. Use a ruler and your metallic silver pen to make the planets look like they are hanging from chains in the sky. Make a straight dotted line extending from the top of each planet to the top of the paper.

6. Add in some finishing touches by filling in the space between the dotted lines with more silver dots, using your ruler to keep things straight. Lastly, use a fine tip blue pen to draw stars all over your paper and in between the dotted lines.

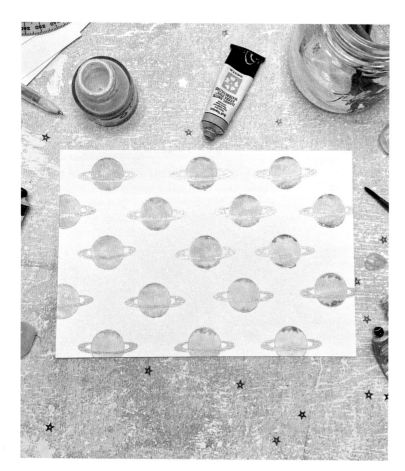

SATURN PATTERN

Creating a pattern of Saturns is a fun little project that you can turn into a background for a journal or add to the front of a card. I like to scan some of my work to my computer so that I can reuse it for several projects. If you are computer savvy, you could also turn your pattern into a digital file and create a lot of other things from it. I made backgrounds for my journals and wrapping paper for small gifts—you could even use it as a background screen on any device.

Supplies

Circle maker tool

Pencil and eraser

6 x 9" (15 x 23-cm) sheet watercolor paper

Paintbrushes, sizes 0, 6 and 4

Metallic gold pen (I used a Sakura Gelly Roll Pen)

Color Palette

 My Teal Mix (page 16)

 My Vanilla Mix (page 16)

 Daler-Rowney Aquafine Gold

 My Pink Mix (page 16)

1. Use a circle maker tool to draw 1-inch (2.5-cm) circles all over the paper. They don't have to be perfectly laid out—just strive to keep the circles evenly spaced about 1 inch (2.5 cm) apart. Make the first circle directly in the middle of the paper to help establish an even pattern. Expand out from there, spacing the circles in a hexagonal shape until you've reached the edges of the paper.

2. Next, you will paint all the circles to look like Saturns. Load a size 6 brush with a little water and apply it to the inside of a circle. Load a size 4 brush with My Teal Mix and brush it along the top and bottom of the wet circle. Then load your brush with My Vanilla Mix and add a little Gold paint to it. Brush it along the Teal Mix, encouraging the colors to bleed together. Then fill in the remainder of the circle with the vanilla and gold mix. While the circle is still wet, load your brush with My Pink Mix and dab it into the vanilla and gold mix in a few spots. Repeat this process for all of the circles. Let them dry.

3

4

5

3. With a metallic gold pen, trace around all of your circles using the 1-inch (2.5-cm) circle on your circle maker tool.

4. Draw Saturn's rings around each circle with the metallic gold pen. To make this easier, turn your paper sideways and draw the rings from top to bottom instead of from side to side. Saturn's rings can be a little tricky to capture because you want to give them the appearance of depth by making the rings smaller as they go behind Saturn but remain a bit thicker in front of Saturn.

5. Add one last finishing touch by loading a size 0 brush with Gold paint and tapping the end of your brush above the paper to create some sparkly stars.

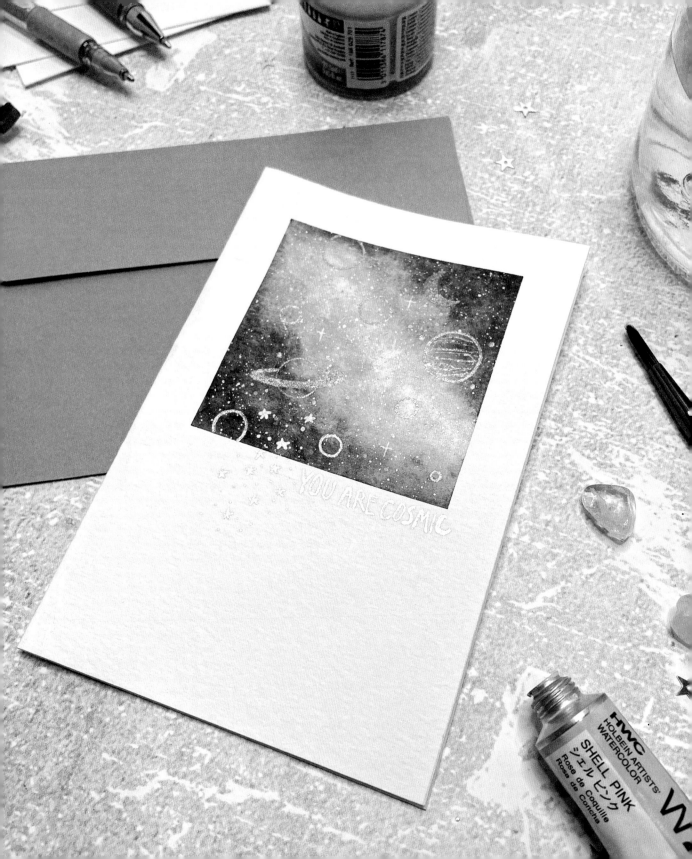

CRAFTING COSMIC PROJECTS

I like to make things that serve a purpose, and it's a bonus if I can put a cosmic twist on them! Sometimes these things can just be a work of art I've created that makes me feel a certain way, so I put it in a prominent place to remind myself of that feeling. I also like to do tactile crafts that require cutting and gluing. Sometimes these crafts make great gifts as well! My favorite project from this chapter is the Milky Way Postcard (page 96). I was inspired by a pen pal who created a handmade postcard for me and sent it in the mail. It was a unique postcard with her art on it, and it was special for her to share that part of her life with me. I decided to create my own postcard, and I mailed it off to a social media friend who gifted me some of her art as well. Get out some craft supplies, and let's make some cosmic projects!

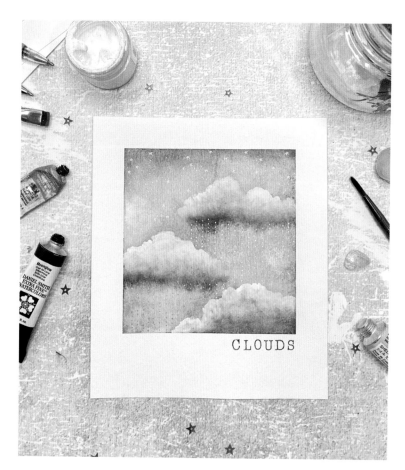

SKY POLAROID

Remember Polaroids? Maybe you still have one of those cameras, or one of the newer iterations of them. I remember the thick white border at the bottom of pictures where I liked to write messages. I thought it would be fun to paint a sky scene and make it look like a Polaroid. For a finishing touch, I stamped one word to describe the picture on the thick white border. These are definitely a fun addition to a journal page or could also be a great framed piece for your desktop.

Supplies

¾" (2-cm)-wide washi tape

6 x 9" (15 x 23–cm) sheet watercolor paper

Ruler

Paintbrushes, sizes 0, 6 and 8

White pen (I used a Uni-Ball Signo Pen)

Metallic silver pen (I used a Pentel Sparkle Pop Pen)

Alphabet stamps and a stamp pad

Scissors or a paper cutter

Color Palette

 My Pink Mix (page 16)

 Daler-Rowney Aquafine Gold

 Daniel Smith Moonglow

 Dr. Ph. Martin's Bleedproof White

 Daniel Smith Bordeaux

1. Apply washi tape around both long edges and one short edge of your paper. Measure 4½ inches (11 cm) from the bottom edge of the washi tape on the short side of your paper and lightly draw a line across the paper. Put another piece of washi tape across the paper at the line to create a square that measures 4½ x 4½ inches (11 x 11 cm).

2. Begin painting the sky scene inside the square. Load a size 8 brush with water and lay down a wash across the square. Using the same brush, apply My Pink Mix all throughout the square. While the paint is still wet, dab some Gold paint throughout the pink. Then dab some Moonglow in cloud shapes throughout the pink as well. Add three cloud shapes that stagger back and forth across the square. Don't overthink the clouds; these should just be rough cloud shapes because you will define them more in Step 3. Let the paper dry.

3. Load a size 6 brush with Bleedproof White to begin refining the clouds. Start dabbing in some white on top of the Moonglow you applied for the clouds in Step 2. The Moonglow will act as a shadow for your clouds, so you are painting in the highlights with white. Blend the white out toward the bottom of your clouds with some water so it mixes slightly with the Moonglow. You will notice that the Moonglow will start to activate a little and that is okay.

4. Load a size 0 brush with some slightly diluted Bleedproof White and lightly tap the brush over the painting, creating a star effect. Do not add too much water to the paint or your stars will end up too big. When the stars are dry, carefully remove the washi tape from your paper.

5

CLOUDS

6

5. Next, add some hand-drawn stars to the background with a white pen. Then use a metallic silver pen and ruler to make rain coming down from the clouds, using the same technique described in Step 5 of the Hanging Planets project (page 77).

6. Once your details are added, either handwrite or stamp a word just below your polaroid on the bottom right. I chose to use some typewriter stamps and an ink pad. You can choose any word you'd like to add below your polaroid, but I chose the word "clouds." After your word is dry, measure 1½ inches (4 cm) from the bottom of your painted piece and lightly draw a line across. Cut off the remainder of the paper along the line, leaving a bigger border at the bottom of your polaroid.

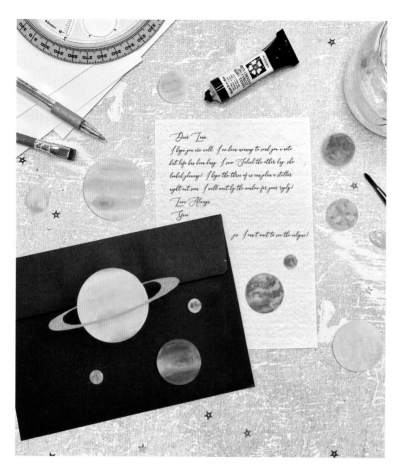

PLANET STICKERS

This is a really fun project and something different to try. Who doesn't love stickers? You're going to make your very own set of planet stickers that you can cut out and use for anything. Sticker paper is actually more durable than you might think and holds up to watercolor quite well. If you don't have access to sticker paper, you can always use small round sticker labels or regular watercolor paper and adhere your designs to a surface with glue or tape. These hand-painted stickers can be a beautiful addition to any letter or craft project.

Supplies

Pencil and eraser

Circle stencil tool

Circle maker tool

8½ x 11″ (21.5 x 28–cm) sticker paper sheet

Paintbrushes, sizes 0, 4 and 6

Metallic silver pen (I used a Pentel Sparkle Pop Pen)

Scissors

Color Palette

 Grumbacher Academy Charcoal Gray

 Dr. Ph. Martin's Bleedproof White

 My Pink Mix (page 16)

 Daniel Smith Piemontite Genuine

 My Vanilla Mix (page 16)

 My Teal Mix (page 16)

 Daniel Smith Cascade Green

 Daler-Rowney Aquafine Gold

 Daniel Smith Mayan Blue Genuine

 Daniel Smith Bordeaux

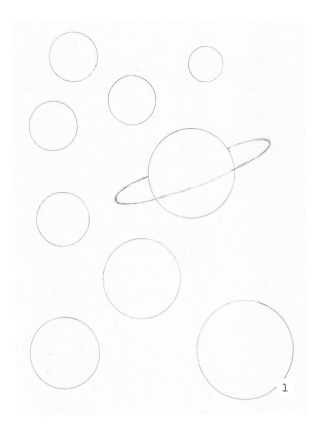

1. Begin by tracing 12 circles in various sizes with a circle stencil and circle maker tool. Nine circles are for planets and three circles are for moons. Try to accurately scale the planets you are drawing with the circle tools. For example, create a large circle for Jupiter and a very small circle for Pluto.

2. Begin painting your planets. If you're not sure what all the planets look like, you can do a solar system Google search for a guide. Just don't be too concerned with getting every detail in for all of the planets. Also, if you are using any type of sticker paper, you don't want to saturate the paper with a lot of water or you risk tearing it. Use the wet-on-dry technique (page 13) for the planets by loading your brush with watercolor and painting each planet without brushing the color back and forth too much. Use very little water to move or blend your paint. Paint the smaller moons in this way as well. Here is a breakdown of the colors used for each planet and a general overview of how to paint each.

Mercury: Load a size 4 brush with Charcoal Gray to paint the planet completely. Then go back in with some less-diluted Charcoal Gray and dab some spots throughout the planet.

Venus: Using My Pink Mix and My Vanilla Mix with a size 4 brush, swirl the colors around inside the planet. There is no right or wrong way to do this; just dab some Pink Mix throughout the planet and then do the same with the Vanilla Mix so the colors bleed together.

Earth: Use a size 0 brush and some Cascade Green to paint a few continents. This doesn't have to be perfect—the goal is to just give the impression of the continents. Then load the same brush with Mayan Blue Genuine to paint the water around the continents. Once this is dry, load the size 0 brush with some diluted Bleedproof White and lightly dab in some clouds.

(continued)

Mars: Load a size 4 brush with My Pink Mix to paint the planet. Then load the same brush with some Piemontite Genuine to dab some darker spots throughout the planet.

Jupiter: Use the Jupiter and the Galilean Moons project (page 69) as a reference for how to paint Jupiter. Start by loading a size 4 brush with My Pink Mix and paint stripes across the planet, leaving spaces in between the stripes. Then load the same brush with My Vanilla Mix and add stripes in between the pink stripes. If you still have some spaces, paint more stripes in as needed. To make Jupiter's Great Red Spot, load a size 0 brush with some Piemontite Genuine to paint an oval shape on the bottom left of the planet. Add a little Pink Mix around and inside the spot to give it more definition.

Saturn: Start by loading a size 4 brush with My Vanilla Mix and paint the entire planet. Working quickly, load the same brush with My Pink Mix and apply it across the middle of the planet like stripes in a few places. Then load My Teal Mix onto a size 0 brush and apply a small amount at the very top and bottom of the planet. With the same brush, swipe some Gold paint across the planet to give it some sparkle. Once the planet is dry, draw Saturn's rings with a metallic silver pen.

Uranus: Load a size 6 brush with My Teal Mix and paint the entire planet. I chose not to make rings around Uranus, but feel free to add them if you'd like with the same metallic silver pen you used for Saturn's rings.

Neptune: Load a size 4 brush with Mayan Blue Genuine and paint the entire planet. Give the blue some variation in color by diluting it with water to paint spots of Neptune that appear lighter and add more blue to create darker spots.

Pluto: Load a size 0 brush with My Pink Mix and paint a small heart shape to the bottom right of the planet but don't fill it in. Then paint the bottom half of the planet with My Pink Mix, working around the heart shape. Add a little Bordeaux at the very bottom to give the Pink Mix more of a red appearance. Then load the size 0 brush with My Vanilla Mix and paint the top half of the planet. Also paint the heart shape with the Vanilla Mix.

Moon: Paint the moon with a size 0 brush loaded with Charcoal Gray. Go back in with some less-diluted Charcoal Gray to add the moon's dark spots.

Titan: Load a size 0 brush with My Teal Mix and paint the entire moon. Working quickly, load the same brush with Gold paint and dab it in a few spots throughout the teal.

Ganymede: Use a size 0 brush loaded with Charcoal Gray to paint the entire moon. Working quickly, load the same brush with My Vanilla Mix and dab it throughout the moon.

3. Let your planets and moons dry completely. Once they are dry, add in some final details such as swirling clouds on Jupiter with some Bleedproof White and a size 0 brush. If needed, redefine the clouds on Earth with some more diluted Bleedproof White and a size 0 brush. Add another layer of silver on Saturn's rings with the metallic silver pen. Let your details dry thoroughly. After they are dry, cut them out with a pair of scissors and stick them on any project you'd like!

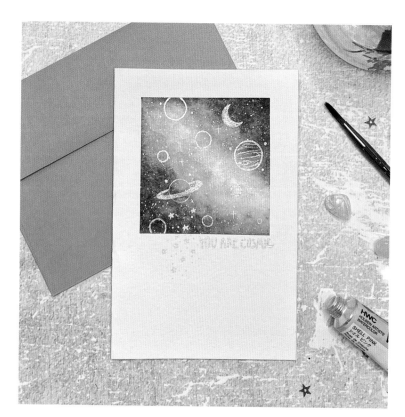

COSMIC CARD

There might be a time when you want to give something special to someone and not just another store-bought card—something that is unique to you. My mother loves when I give her pieces of my art! In this project I will show you how to create a greeting card that is unique to you and ready for gifting. You could also keep it for yourself and put it in a journal or frame.

Supplies

6 x 9" (15 x 23–cm) sheet watercolor paper

Ruler

Pencil and eraser

¼" (6-mm)-wide washi tape

Paintbrushes, sizes 0, 6 and 8

Circle maker tool

White pen (I used a Uni-Ball Signo Pen)

Metallic silver pen (I used a Pentel Sparkle Pop Pen and a Uni-Ball Signo Pen)

Scissors or a paper cutter

Color Palette

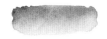
Daniel Smith Moonglow

My Pink Mix (page 16)

Daniel Smith Bordeaux

My Vanilla Mix (page 16)

Daler-Rowney Aquafine Gold

Dr. Ph. Martin's Bleedproof White

1. Find the middle of your paper on the long sides by measuring to 4½ inches (11 cm) and making a light mark with a pencil on both sides. Use the marks to lightly draw a straight line across the width of the paper. Then measure ½ inch (1.3 cm) from the end of the paper on each 6-inch (15-cm) side. You will cut off those later. Next, position the paper horizontally so both 9-inch (23-cm) sides are at the top and bottom. You are going to tape off a 3½ x 3½-inch (9 x 9-cm) square on the right side of your paper. This will be the front of the card on which you will paint a scene. Apply washi tape along the top edge of the right side of the paper and along the guidelines you drew. Measure 3½ inches (9 cm) down from the top piece of washi and tape off your square at the bottom.

2. Start by imagining a diagonal line from the top left of your square to the bottom right. This is where the galaxy will be. Load a size 8 brush with Moonglow and apply it to the opposite corners of your imaginary diagonal line. You just want to cover the very corner with the Moonglow. Next, using the same brush, apply some of My Pink Mix as well as some dabs of Bordeaux next to the Moonglow. Then on the imaginary diagonal line, add some of My Vanilla Mix to connect both corners. Let these colors swirl and blend. While the middle of your galaxy is still wet, use a size 6 brush to dab in some Gold paint to give it some shimmer. Let the paper dry completely.

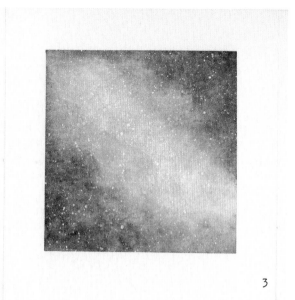

3

4

3. Load a size 0 brush with some slightly diluted Bleedproof White and tap the brush over your square to create a star effect. Do not add too much water to the paint or your stars will end up too big. Do this all over your square, but really concentrate on the middle of your galaxy. After the stars are completely dry, carefully remove the washi tape around your painting.

4. Use a circle maker tool and a metallic silver pen to draw all nine planets and a crescent moon. Make some rough sketchy lines inside Jupiter, giving it a little detail. Give Saturn some rings and color in the crescent moon with the silver pen. For a few more details, add small moons around Saturn and Jupiter and fill them in with the silver pen. Next, use a white pen to add some hand-drawn stars throughout the galaxy by making a dot of white and then drawing a cross or X through the circle. Finally, dot in some more stars all over your scene with the silver pen.

5

5. Use a silver pen to freehand write "you are cosmic" at the bottom right corner of your galaxy scene. You can also choose another phrase if you'd like. Use the same pen to draw a few stars to the left of the phrase and a few dots to give it a little sparkle!

6. Finally, trim off the ½-inch (1.3-cm) strips you measured on the 6-inch (15-cm) sides of the paper. Use scissors or a paper trimmer to give it a clean edge cut or fold the ends over a straight edge, crease them back and forth, then tear the paper at your marks. This will give it a deckled edge feel. Fold the paper in half and crease it a few times really well to create your 4 x 6-inch (10 x 15-cm) card. Send it off in the mail to your bestie!

6

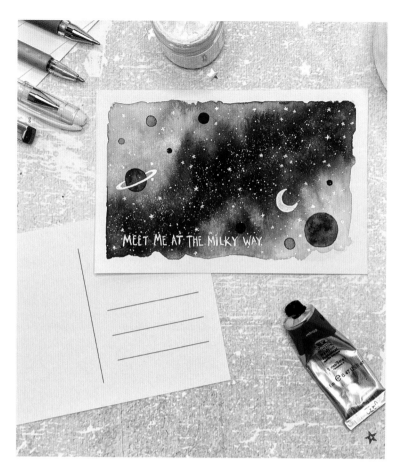

MILKY WAY POSTCARD

Postcards are such a fun and inexpensive way to say hello to someone you haven't talked to in a while. Even better, you can customize your postcards with some Milky Way watercolor art that will delight your recipients. Postcards are also exciting to send to a pen pal or just to embellish your art journal with. This project doesn't have to be dropped in the mail or put in a journal though. It could also be a lovely art piece to display anywhere you need a touch of the cosmos!

Supplies

½" (1.3-cm)-wide washi tape

4 x 6" (10 x 15-cm) sheet watercolor paper

Scrap piece of cardboard or foam core (at least 4 x 6" [10 x 15 cm])

Paintbrushes, sizes 0, 4 and 8

Pencil and eraser

Circle maker tool

White pen (I used a Uni-Ball Signo Pen)

Metallic silver pen (I used a Pentel Sparkle Pop Pen)

Ruler

Permanent, waterproof black pen (I used a Copic Multiliner Pen)

Color Palette

 Winsor & Newton Indigo

 Daniel Smith Iridescent Moonstone

 Dr. Ph. Martin's Bleedproof White

1. Use a ½-inch (1.3-cm)-wide piece of washi tape to tape the paper down to a scrap piece of cardboard or foam core to prevent your paper from bubbling up when you put down the watercolor.

2. With a size 8 brush, apply a wash of water across your page where you intend to put down paint. Load the same brush with Indigo and apply it almost diagonally across the card. Let the water carry the blue outward, getting lighter as it spreads but leaving the blue saturated in the middle. Don't worry about what shape the Milky Way takes— just let it flow organically. You can push the blue watercolor outward a little with a wet brush and let it get lighter as it gets closer to the edge of the wash you laid down. For some added sparkle, dab a little bit of Iridescent Moonstone into the blue while it's still wet. Let the paper dry.

3. Use a pencil and a circle maker tool to lightly draw a few circles in different sizes around where you've painted your Milky Way. Next, lightly freehand draw a moon or use the circle maker to create a crescent moon by placing a smaller circle inside a larger circle.

Note:

To qualify for mailing at the First-Class Mail postcard price, your postcard must be rectangular in shape. The dimension must be at least 3½ x 5 inches (9 x 13 cm) and 0.007 inch (0.2 mm) thick, and no more than 4¼ x 6 inches (11 x 15 cm) in size and 0.016 inches (0.4 mm) thick.

4. Use a size 4 brush to paint your circles with different shades of Indigo. Adding more water to the blue will make it lighter but using less water will make the blue very saturated and appear darker. Paint your moon and Saturn's rings with Iridescent Moonstone. Let the paper dry.

5. Load a size 0 brush with some slightly diluted Bleedproof White and lightly tap it above your painting to flick paint over it, creating a star effect. Do not add too much water to the paint or your stars will end up too big. Vary the amount of splatters, making more stars in the very middle of your Milky Way. You can cover your planets with a scrap piece of paper so you don't also splatter them with stars.

6. After the stars are dry, add some finishing touches by hand-drawing some stars with a white pen and a metallic silver pen. Add pops of sparkle by adding a few silver circles and dots.

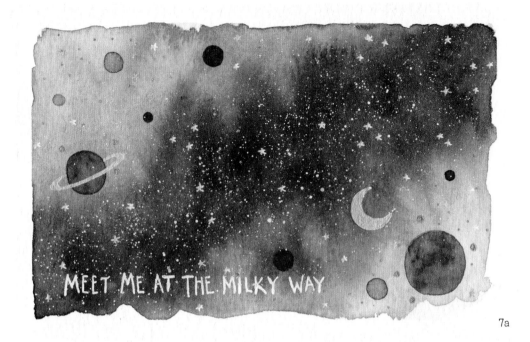

MEET ME AT THE MILKY WAY

7a

7b

7. After you are finished embellishing your Milky Way, add the words "Meet Me at the Milky Way" with your white pen (7a). If you plan to send your postcard in the mail, turn it over and draw a line down the middle of the card with a permanent, waterproof pen (7b). To the right of that line, about halfway down the card, you will address your postcard with your recipient's address. Make sure you leave enough space to place a stamp at the top right of your card. To the left of the middle line, write your message. You are ready to send your hand-painted card!

CELESTIAL BOOKMARK

Did you know that everyone has at least two astrological signs? When you were born, the sun appeared to be in a specific constellation in the night sky and so did the moon. You have a sun sign, a.k.a. your zodiac sign, and a moon sign. Making a hand-painted bookmark with your astrological signs is a fun and useful project. The process is very easy, and the bookmarks can be customized for gift-giving.

Supplies

Pencil and eraser

Ruler

4 x 8" (10 x 20–cm) sheet watercolor paper

Paintbrushes, sizes 0, 4 and 8

White pen (I used a Uni-Ball Signo Pen)

Circle maker tool

Metallic silver pen (I used a Pentel Sparkle Pop Pen)

Scissors or paper cutter

Laminating paper (optional)

Hole punch

4–6 (10–12" [25–30–cm]) pieces string

Color Palette

 Winsor & Newton Indigo

 Dr. Ph. Martin's Bleedproof White

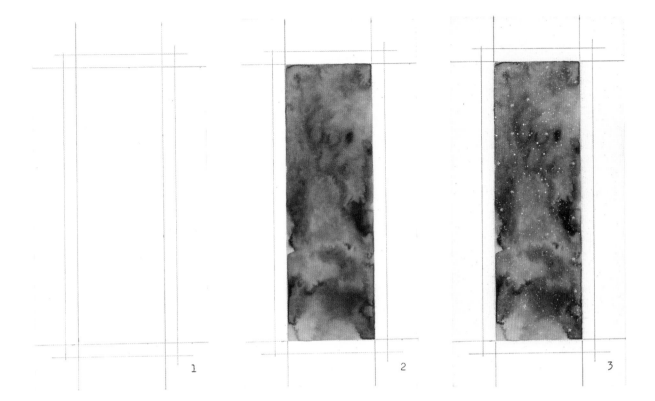

1. With a pencil and a ruler, make a 1-inch (2.5-cm) border all the way around your paper, leaving a 2 x 6-inch (5 x 15-cm) rectangle. Next, make a second border that measures ¼ inch (6 mm) from the outside edges of the 2 x 6-inch (5 x 15-cm) rectangle you just made.

2. Load a brush with water and apply a wash in the 2 x 6-inch (5 x 15-cm) rectangle. Try not to get any on the outer ¼-inch (6-mm) border, because that will be part of the bookmark. Next, load a size 8 brush with Indigo and apply it to the wet area of the paper. This color swirls around and bleeds very nicely, so allow it to do that. Dab some color on the corners and edges and let it bleed toward the middle and join. Let the paper dry completely.

3. Load a size 0 brush with some diluted Bleedproof White and lightly tap it over your painting, creating a star effect. Do not add too much water to the paint or your stars will end up too big. Use a white pen to hand-draw a few small star shapes. Just add a few more now and then in the spaces during the last step.

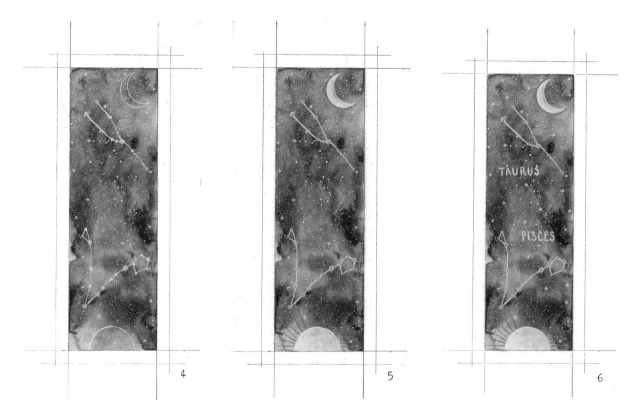

4 5 6

4. If you don't already know, look up what your sun and moon signs are and what their constellations look like. My sun sign is a Pisces and my moon sign is a Taurus, so I drew the constellation for both of those signs on my piece. Use your white pen to draw the constellations, one toward the top of your bookmark and the other toward the bottom. Next, use your circle maker tool and a white pen to draw a crescent moon next to your moon sign and a sun next to your sun sign.

5. Load a size 4 brush with some diluted Bleedproof White to paint your moon and sun shapes. Once those are dry, trace around the outside of the moon and sun with the metallic silver pen for a little extra sparkle. Add rays extending out from the sun with the same pen and make dots of sparkle in each of the stars/circles in your constellations.

6. For some finishing touches, handwrite the names of your constellations just below or above the constellations themselves with a white pen. Then fill in more star shapes in areas that have none. After that, you'll need to erase some pencil lines that cross at the corners and are just inside your ¼-inch (6-mm) border around the bookmark. Leave the other lines because these will serve as guides when you cut out the bookmark.

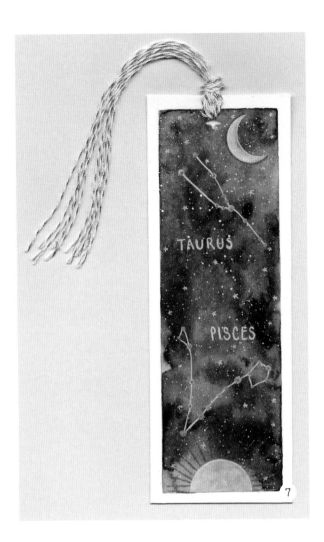

7. Cut out the bookmark along the ¼-inch (6-mm) border you left or use a paper cutter. You should be left with a ¼-inch (6-mm) white border around your painted piece. If you decide you want to laminate your bookmark, do so at this point. I left mine unlaminated. Next, punch a hole in the very top middle of your bookmark, just inside the painted part where it meets the white border. Gather your pieces of string so that the bunch is even on both ends and fold the bunch in half. Feed the folded ends through the hole you punched in your bookmark about halfway. Then take the loose ends and feed them through the folded bunch to make a knot. Cut off any excess string at the end if it's too long.

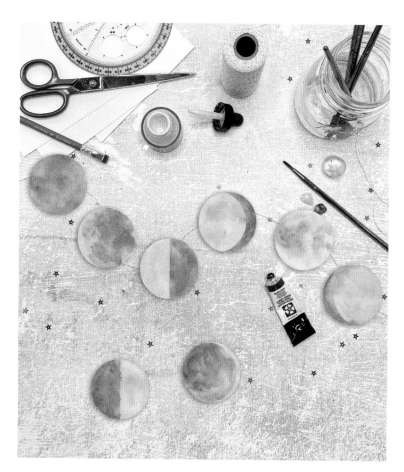

MOON PHASE GARLAND

This is probably my favorite crafty art project! You're going to paint some moon phases to string and hang anywhere. These garlands are super cute and fun to decorate your home with. They will be unique to you and your painting style—one-of-a-kind decor pieces that you cannot find in the store. These garlands are a nice addition to walls and mantels, and if you celebrate the holiday season, they also make beautiful tree decorations and gift wrap embellishments.

Supplies

Circle stencil tool

Pencil and an eraser

8 x 8" (20 x 20–cm) sheet watercolor paper

Paintbrushes, sizes 4 and 6

Scissors

Twine or hemp

Ruler

Tape

Color Palette

 Daniel Smith Shadow Violet

 Daler-Rowney Aquafine Gold

1

2

1. Using your circle stencil tool and a pencil, lightly draw eight 2½-inch (6-cm) circles, arranging them three across and three down on the paper.

2. Lightly draw the moon's phases in the circles. Refer to the Moon Phase Wall Art project (page 27) for the shape of each phase. Your moon phases should go in the following order, even when you are ready to string them.

 1. New moon: Just a circle

 2. Waxing crescent: Sliver of moon shadow to the left

 3. First quarter: Split the circle in half

 4. Waxing gibbous: A circle three-quarters of the way into the circle, leaving a crescent for a shadow on the right

 5. Full moon: Just a circle

 6. Waning gibbous: A circle three-quarters of the way into the circle, leaving a crescent for a shadow on the left

 7. Third quarter: Split the circle in half

 8. Waning crescent: Sliver of moon to the left

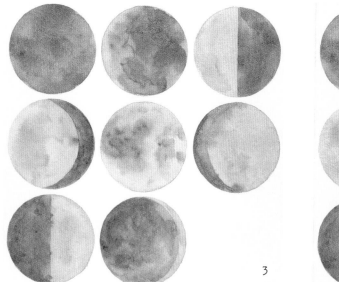

3

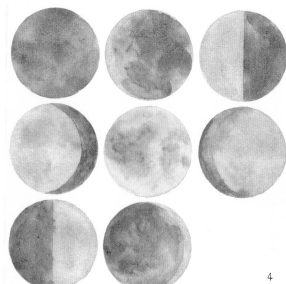

4

3. Use Shadow Violet to paint both the moon and the shadow in each circle. The shadow side of the moon will need to be painted a little darker than the moon, and you can do this by layering the color to make it darker. Begin by loading a size 6 brush with Shadow Violet and paint the shadow of the moon phase. Use a little water to blend out the paint in your circle where the actual moon would be. Darken up the shadows by adding more paint to those areas. The new moon is the only phase that should be totally dark with layers of color. Once all the moon phases are painted, let the paper dry.

4. Load a size 4 brush with some diluted Gold paint and lightly brush it over the lighter parts of your moons for some added sparkle. You just want a very subtle, transparent shimmer. Let the paper dry.

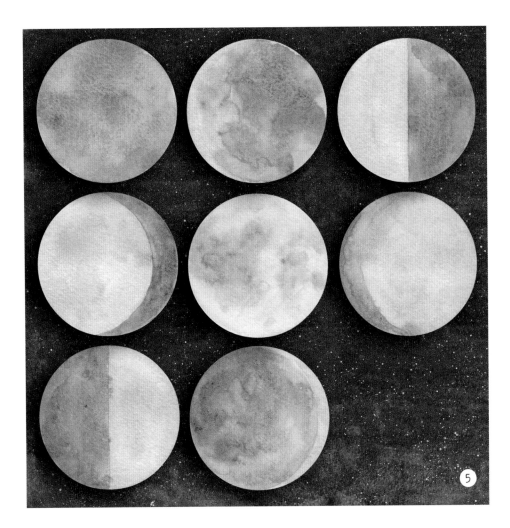

5. Now you can cut out all of your moon phases and arrange them in a line for stringing, leaving about 1 inch (2.5 cm) of space between them. The string you use for your garland should be sturdy like twine or hemp—do not use thread. Measure across your moon phases that are laid out with your string, leaving about 5 inches (13 cm) on each end so that you have enough room to knot a loop on the end to hang it. Flip over your phases so you see the backs of the circles and lay the string across them evenly. Use some tape to adhere the string to the backs of your moon phases. At each end, tie a knot where you are leaving a loop to hang your garland.

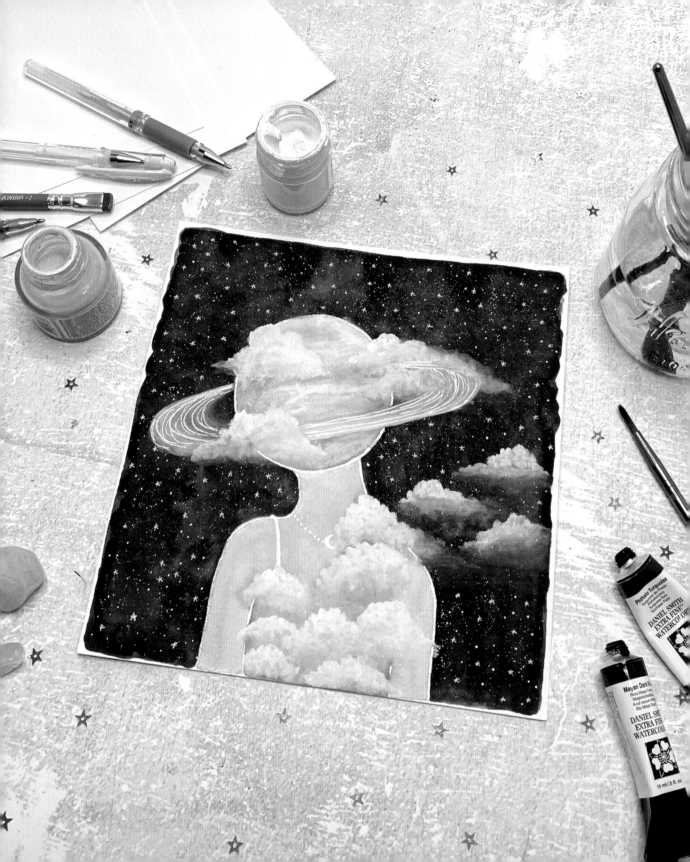

CREATE DREAMY, ETHEREAL ART

I like to push boundaries when I create my artwork, but in a beautiful and surreal way. I enjoy depicting subjects with a mix of natural and unreal elements and creating art that isn't totally believable. It is also exciting to allow your imagination to wander into another world and create the imaginary. In this chapter, you will mix the real with the unreal and achieve stunning results!

My favorite project in this chapter is the Ethereal Cosmic Art piece (page 122). Part collage and inspired by ancient Renaissance and Greek sculptures, it's a fun mixed-media project that offers a lot of visual interest.

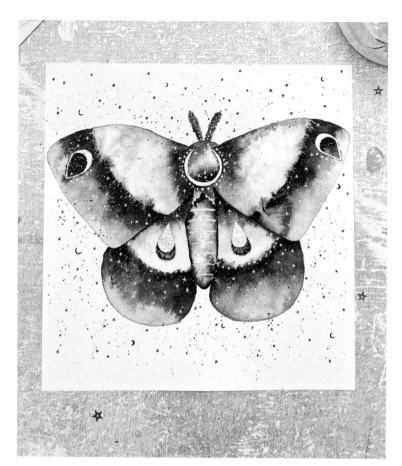

MOON MOTH

This project can turn out really unique and beautiful. Moths look similar to butterflies, but their wings are shaped and patterned differently. It is fun to exaggerate those patterns in this project and add a scattering of stars to the entire piece. Look for a photo of a moth you like by doing a simple search online. Use that photo for reference so you can re-create the basic shapes of the moth. With your cosmic glasses on, use your imagination to decorate your moth with stardust!

Supplies

Pencil and eraser

8 x 8″ (20 x 20-cm) sheet watercolor paper

Circle maker tool

Warm gray waterproof pen (I used a Copic Multiliner Pen)

Paintbrushes, sizes 0, 4 and 6

Fine tip blue pen (I used a Pilot G-Tec-C4 Pen)

Metallic silver pen (I used a Pentel Sparkle Pop Pen)

White pen (I used a Uni-Ball Signo Pen)

Color Palette

 Dr. Ph. Martin's Hydrus Payne's Gray

 Dr. Ph. Martin's Bleedproof White

1

2

1. Lightly sketch a moth in the middle of your paper. Add a few details on the wings and body but not too many, because you can add those after you've painted your moth. As I've said before, don't overthink it! This isn't supposed to be a technical, scientific drawing of a moth, so you are encouraged to exaggerate the markings on its wings. Draw a crescent moon in the middle of the moth's wings using a circle maker tool, then draw teardrop shapes on the wings with a crescent moon shape inside each.

2. Once you've got your moth sketched out in pencil, use a waterproof fine tip pen to trace over the pencil lines. I used a Copic Multiliner Pen in Warm Gray, but a black Sakura Micron Pen would also work well. Once you've traced your moth, erase any sketch lines that are left.

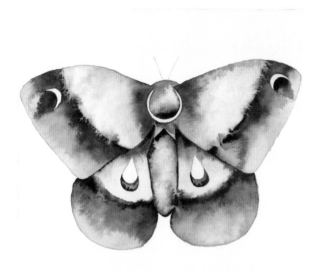

3

3. Load a size 6 brush with water and apply a wash to the top left section of your moth to the tip of that wing. Then load your brush with Payne's Gray and brush it throughout the wash. Let it bleed out naturally in the wash. Repeat this process for the entire moth, but leave the crescent moon and teardrop shapes you sketched unpainted for now. Notice how I've put a heavier concentration of Payne's Gray in certain areas, such as where two edges meet or where there would be a shadow, for example. You'll want to variegate the color a little so that the moth's details stand out. Once the body and wings are painted, go back and paint any details with a size 4 brush. Only paint the bottom portions of the teardrop shapes in the moth's upper wings and leave the crescent moon shapes unpainted. You will color them in with a metallic silver pen in Step 4. Then paint the crescent moon shapes on the two bottom wings, but leave the remainder of the teardrop shapes unpainted. Let your moth dry completely.

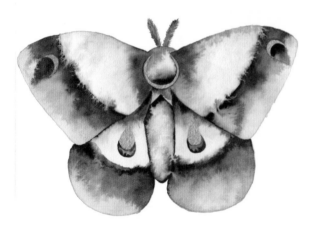

4

4. Use a silver metallic pen to color in the details left unpainted. Color in the half-moons on the two top wings and the remainder of the teardrop shapes on the two bottom wings. Then color in the crescent moon between the two top wings with the same pen. Once that is dry, paint the moth's antennae. To make the antennae furry-looking, load a size 0 brush with Payne's Gray and paint over the single lines you sketched for the antennae. Then add a little more water to your brush and make small strokes upward and outward from the single line. Let the antennae dry.

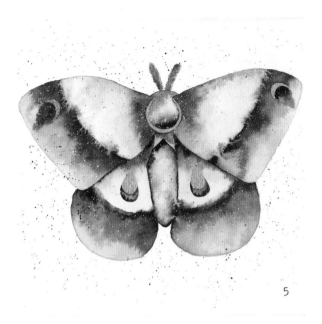

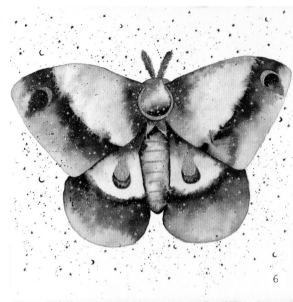

5. Next, load a size 0 brush with some slightly diluted Bleedproof White. Tap the end of the brush to flick the paint all over your moth, creating a star effect. Don't add too much water to the paint or your stars could end up too big. Think tiny, petite stars! After the stars are dry, load the same brush with some slightly diluted Payne's Gray and repeat the process, but this time flick the paint all over your entire piece so that it appears like stars are popping out from the moth. Let the stars dry.

6. Finally, add in some details. Use a white pen to draw some little white stars on your moth, concentrating them in the darker areas. Then use a fine tip blue pen to freehand draw tiny little stars and moons throughout the background of your piece. Trace around some of the moth's details with a metallic silver pen. Lastly, with the same pen, add small dots all over the entire piece for little pops of sparkle.

LINE ART GODDESS

I really like this piece because it is fun and abstract. Line art figures are really simple to do, but your brain will try to overthink them. Don't let it! If you've ever taken a figure drawing class, you've more than likely had to draw a figure with a continuous contour line without lifting your pen off the paper. This project is similar but much simpler. You're going to create a line art face by looking at your own face or someone else's, either in a photo or in person. Then you're going to add a cosmic twist to your line art by adding some galaxy hair!

Supplies

Paintbrushes, sizes 0, 4 and 8

6 x 9" (15 x 23-cm) sheet watercolor paper

Pencil and eraser

Warm gray waterproof pen (I used a Sakura Gelly Roll Moonlight Pen)

Circle maker tool

Metallic gold pen (I used a Sakura Gelly Roll Pen)

White pen (I used a Uni-Ball Signo Pen)

Color Palette

 My Pink Mix (page 16)

 Daniel Smith Moonglow

 Daler-Rowney Aquafine Gold

1. Load a size 8 brush with some water and apply a wash that extends vertically from the top left corner of your page to the bottom right. Organically move the water down the page—you don't want a straight line from corner to corner. Imagine if you spilled a glass of water across your page diagonally and try to make the edges of the wash somewhat uneven and wavy. Next, load your brush with My Pink Mix and work quickly to brush it throughout your wash all the way down the paper, adding in more color where needed. While the paint is still wet, dab a little bit of Moonglow along the edges of your wash and let it blend into the Pink Mix, encouraging it with water if needed. Next, load your brush with some Gold paint and brush it right down the middle of the Pink Mix. Let the paper dry.

2. Starting at the bottom right corner of your piece, sketch a continuous contour line drawing of a face. Don't overthink it! A continuous contour line drawing involves drawing something you are looking at while trying not to pick up your pencil. Your entire drawing should consist of one continuous line. It's very abstract! Practice on a scrap piece of paper if you need to by drawing a simple face with one continuous line. In this example, an eye and lips can be drawn separately, but still as one continuous contour line. Once you've practiced and have the face you want, draw it on your piece. Use a pencil first so you can erase if needed, but erasing is not recommended! Then trace over the pencil line with a warm gray waterproof pen. I used a Sakura Gelly Roll Moonlight Pen in Warm Gray, but a Sakura Micron or any other fine tip pen that is waterproof will work.

3. With a size 4 brush, freehand paint some circles throughout your galaxy to represent the nine planets. Paint them with My Pink Mix, and while they are still wet, you can dab in a little Moonglow to darken them up and add depth. Make sure each planet is appropriately sized. For example, make Jupiter the biggest circle and Pluto the smallest. You don't have to paint all nine planets inside the galaxy; you can also paint a couple outside the galaxy. Load a size 4 brush with some Pink Mix and give your contour line face some light rosy cheeks and lips. Once these are dry, create some stars all over your piece by loading a size 0 brush with some diluted Pink Mix and tapping it all over above your piece. Don't add too much water to the paint or your stars will end up too big. Repeat that process with some Moonglow. Let the stars dry.

4. Load a size 0 brush with Gold paint to make Saturn's rings and Jupiter's bands and Great Red Spot. Give the planets a little more detail and paint a crescent highlight on one side of the planet. With the same brush, paint some gold moons around Jupiter and Saturn. Then, use a circle maker tool and a metallic gold pen to create a crescent moon on your contour line face just above the left eye. Paint the crescent moon with Gold paint.

5. With a white pen, draw little stars throughout the galaxy hair. Then dot your galaxy with the white pen all around the galaxy hair.

6. Lastly, on the right side of your contour line face, load a size 0 brush with Gold paint and add some botanicals. Paint a few lines for stems coming out from behind her ear and add leaves to the stems. Add a small rose just between her cheek and ear by creating half-moon shapes that twirl around each other in a circle. (Refer to the Crescent Moon with Botanicals project [page 23] for more tips to make botanicals.) With the same brush and Gold paint, add stars throughout your galaxy, adding a small star for your goddess's right eye and also adding a few around her left eye. Finally, load the same small brush with more Gold paint and flick it all over your painting to make some sparkle stars.

SATURN HEAD

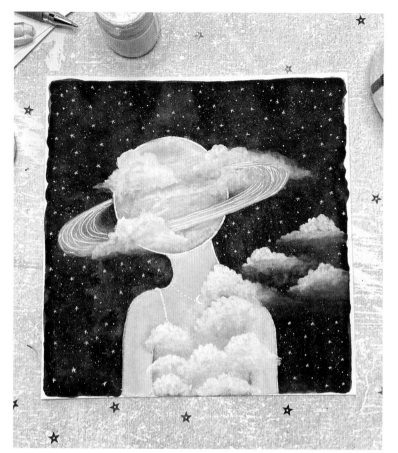

I prefer my head in the clouds! I was inspired to create this piece because of my love for Saturn and how I'm constantly dreaming of what the universe looks like. This is a fun, surreal piece that you can turn into a self-portrait if you'd like. It's best executed when you don't overthink it. You might be worried that the torso of her body will be challenging, but if you break it down into small shapes, it's basically a small rectangle on top of a large rectangle with rounded edges. Feel free to personalize this project and make it your own with any additional details!

Supplies

Circle stencil tool

Pencil and eraser

8 x 8" (20 x 20-cm) sheet watercolor paper

Paintbrushes, sizes 0, 4, 6 and 8

White pen (I used a Uni-Ball Signo Pen)

Metallic silver pen (I used a Pentel Sparkle Pop Pen)

Color Palette

 Daniel Smith's Mayan Dark Blue

 My Pink Mix (page 16)

 My Teal Mix (page 16)

 My Vanilla Mix (page 16)

 Dr. Ph. Martin's Bleedproof White

1. With a circle stencil tool and a pencil, lightly draw a 3-inch (7.5-cm) circle slightly above and to the left of the center of the paper. Make sure there is enough room underneath your circle to draw both a neck and torso, and also enough room to make Saturn's rings around the circle without running off the side of the paper. Then, starting at the bottom of the circle you just drew, lightly sketch a body from the neck to mid-torso. This doesn't have to be perfect. When drawing the neck, make the right side of the neck a little longer than the left so the head looks like it is tilted slightly to the left. Also, when drawing the right shoulder, drop it down slightly lower than the left one.

2. Once you've got your torso drawn, load a size 8 brush with Mayan Dark Blue and use the wet-on-dry technique (page 13) to begin painting the background. You will want to make sure you are keeping the background dark for this piece, so don't use too much water to move the color around. Be careful not to paint inside the body and head you just sketched. Let the paper dry completely.

3. Next, paint Saturn using My Pink Mix, My Teal Mix and My Vanilla Mix. Saturn is a swirl of all three of these colors, so here you are going to use the wet-on-wet technique (page 13). Begin by loading a size 6 brush with water and applying a wash inside the circle you sketched on the paper. Then load the same brush with My Pink Mix and dab it throughout the wash in various spots. Working quickly, load the brush with My Vanilla Mix and do the same by dabbing it throughout the wash. Encourage the Pink Mix and the Vanilla Mix to blend and bleed together. Quickly load your brush with some of My Teal Mix and dab it throughout the wash. Encourage the Teal Mix to blend around the Pink Mix and Vanilla Mix as well. Let Saturn dry!

4. Paint the torso with My Pink Mix and My Teal Mix. Using the wet-on-wet technique once again, load a size 6 brush with water and apply a wash inside the arms, neck and torso. From the neck down to about mid-chest on the torso and down each arm, apply My Pink Mix. Working quickly, load the brush with My Teal Mix and paint the remaining portion of the torso, which is her dress. Encourage the Teal Mix to bleed into the Pink Mix at the top of the chest and over to her arm on the right side, which would be her left arm. Load a size 4 brush with some Mayan Dark Blue and paint a little at the bottom of her torso, where the inside of her arms touches her dress, to add a little bit of a shadow. Let the paper dry.

5. After the torso is dry, load a size 4 brush with Bleedproof White and dab a few tufts of clouds over the teal part of the torso, where her dress is. When dabbing in the Bleedproof White, apply the most white at the top of your clouds and then use water to blend them out toward the bottom. Carry the clouds over her arm and into the sky background by creating more tufts of clouds with some diluted Bleedproof White. These clouds should appear hazy and a little smoky. Add a few more diluted clouds that cross over Saturn or her head. Then, load a size 0 brush with more diluted white and flick stars all over the background and over the Saturn head by tapping the brush over the painting. Let it dry.

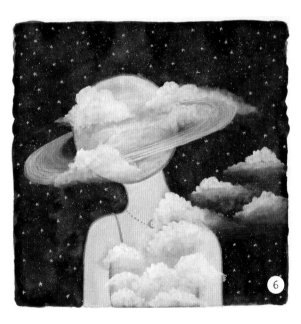

6. Finally, add in the finishing details. Using a pencil, lightly sketch a ring around Saturn or her head, then load a size 4 brush with some more Bleedproof White and paint the ring, keeping the outer edges of the ring thicker when the ring passes in front of her face. Remember not to connect the ring at the back of the head to make it appear as though the ring is around Saturn. Once the paint is dry, draw small stars throughout the background with a white pen. Then outline the head and torso of her body with a metallic silver pen. Remember not to draw completely around Saturn, stopping where the ring passes in front. With the same pen, make a few lines through Saturn's ring to give it a little sparkle. Next, freehand draw a crescent moon in the middle of her chest, toward the bottom of her neck, and color it in with the metallic silver pen. Add dress straps from the top of her cloud dress that go up and over her shoulders. Lastly, with the silver pen, dot in some sparkles throughout the entire piece.

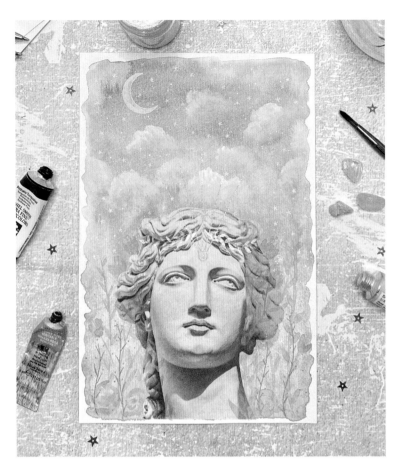

ETHEREAL COSMIC ART

You are going to create a mixed-media piece that has all the ethereal art vibes! Working with a few different mediums can bring your art to another dimension. For this particular project, you are going to use a printed picture of a Greek or Roman marble sculpture and some matte medium to adhere it to your piece. My image is an Adobe Stock image from the artist Neurobite, but you can use whatever image you like best! I love mixing elements from the Renaissance period or Greek and Roman mythology into my cosmic art, as it creates a very dreamy, ethereal feel.

Supplies

Paintbrushes, sizes 0, 4, 6 and 8

6 x 9" (15 x 23–cm) sheet watercolor paper

Black and white photo of an ancient marble statue

Scissors

Matte medium (see Note on page 126)

White pen (I used a Uni-Ball Signo Pen)

Circle maker tool

Metallic gold pen (I used a Sakura Gelly Roll Pen)

Color Palette

My Teal Mix (page 16)

My Pink Mix (page 16)

Dr. Ph. Martin's Bleedproof White

1. First, load a size 8 brush with water and apply a wash to the top half of your paper and the bottom half, leaving a thin line in between of dry paper. Next, load your brush with My Teal Mix and brush it throughout the wash on the top of your paper to make the sky. Keep adding paint until you reach the end of the wash area on the upper half of the paper. Then load your brush with My Pink Mix and brush it throughout the wash on the bottom half of your paper. Work quickly and add more Pink Mix until you reach the bottom of the paper. Load your brush with some water and begin blending the two washes of colors in the middle of the paper where you didn't put down a wash. Move your brush back and forth through each color so that they blend and bleed into one another. Let the paper dry completely.

2. Load a size 6 brush with Bleedproof White to add some clouds to the sky. Keep the tops of the clouds white and wash them out toward the bottom with a little water. This will make the white look translucent and give the clouds a naturally darker appearance on the bottom. Next, load a size 0 brush with some slightly diluted Bleedproof White and add some stars by tapping the brush above the paper, creating a star effect all over. Let your clouds and stars dry.

3. Next, you're going to paint some flowers and botanicals at the bottom of your paper with My Pink Mix. Don't overthink painting these flowers, and don't worry about making them look exactly like a particular flower! None of the flowers I paint are an exact technical replica of a specific flower. Instead, I like to give the impression of a flower by loosely painting what I think a flower looks like.

Use a size 4 brush to start painting some botanicals, such as a stem and leaves. Paint a few of these sporadically on the bottom of your paper with the Pink Mix. You don't need to paint them all the way across your page because you are going to glue down a cutout of a statue in the middle of your page, but you'll want to almost cover the entire page. After you have a few botanicals, add some stems and then create some loose organic-looking shapes for flowers. The easiest way to paint loose organic flowers is to simply add a dab of paint to your paper and use a little water to push the color outward slightly in a petal shape. Another way is to create little half circles that continue to fit around each other in a small circle. You can also refer to the Crescent Moon with Botanicals project (page 23) and Floral Crescent Moon project (page 31) for details about other ways to create botanicals. Add more stems with leaves or botanicals where spaces need to be filled. After that layer dries, if you find some of your botanicals and flowers appear too light, add another layer on top of your first. Let the paper dry.

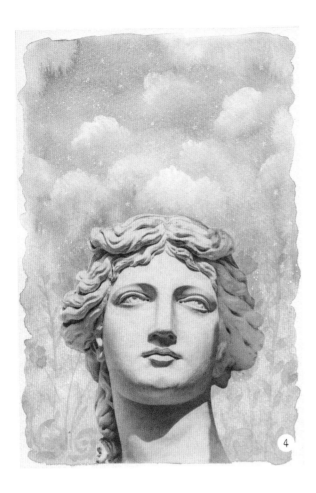

4. Find an image online of an ancient marble statue that is fairly large and that you are able to use just the portion from the neck up. As long as you aren't trying to sell your piece, you can use any photo of a statue that you can find on the internet. Print out the image in black and white, preferably with a laser printer so that the printer ink remains permanent. If you don't have access to a laser printer, use an inkjet and seal it with a matte medium after adhering it to your watercolor paper. Contour cut out your statue and if you need to, snip off the portion from the neck down. Use a matte medium to adhere your statue image to the bottom middle of your paper where the flowers are. If you printed out your statue with a laser printer, you don't need to seal your paper—just glue it down with the matte medium of your choice. Make sure to get the matte medium thoroughly around the edges so they don't curl up. Let the painting dry.

5. Blend in your statue with the background a bit by painting a few botanicals with the same Pink Mix on the sides of your statue, so it looks like your statue is coming out of the flowers. Next, draw a crescent moon with a white pen and a circle maker tool in the top left corner by the clouds. Lightly paint it with some Bleedproof White.

6. Finally, add in a few details. Draw some white stars throughout the sky with your white pen. Then use a metallic gold pen to draw a few twigs among the flowers. Dot in some sparkles throughout your entire piece. Lastly, you're going to add what I like to call "the mind's eye." Using your circle maker tool and a gold pen, draw and color in a small circle right in the middle of your statue's forehead. Then draw another circle around the first. With the same gold pen and a ruler, draw rays extending out from the outer circle toward the sky and add a little dash and dot at the end of your rays.

Note:

Matte medium acts as a glue that you are able to paint on, and it will also seal your cutout if you printed it with an inkjet printer. You can get matte medium at any craft store. I like to use Liquitex Matte Medium, but another good one is Mod Podge Paper, Matte Finish.

CELESTIAL ART JOURNAL

Having a place to keep some of your creative processes and attempts is a wonderful thing! Art journals are my heart and soul. I have hundreds of journals and loose art pieces that I put in journals. You can buy an art journal or you can easily make one. It doesn't need to be very big. I find that an 8 x 5-inch (20 x 13-cm) size is perfect. You can also fold five sheets of 9 x 12-inch (23 x 30.5-cm) mixed-media paper in half and staple the middle. Or, if you like to sew, you can stitch the middle up with some nylon thread. Voilà—a handmade art journal!

Supplies

8 x 5" (20 x 13-cm) art journal or 2 (6 x 9" [15 x 23-cm]) sheets watercolor paper

Paintbrushes, sizes 0, 4, 6 and 8

Circle maker tool

Metallic silver pen (I used a Pentel Sparkle Pop Pen)

White pen (I used a Uni-Ball Signo Pen)

Color Palette

 Daniel Smith Moonglow

 Daniel Smith Payne's Gray

 Daniel Smith Bordeaux

 Dr. Ph. Martin's Bleedproof White

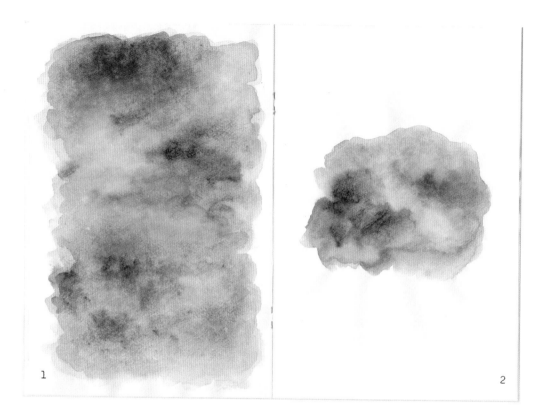

1. Open up your journal to a blank spread and give it a good crease down the middle. Load your size 8 brush with some water and apply a wash across the left page, covering most of it but being careful not to spill it over the edges or into the crease of the journal. Load your brush with Moonglow and begin randomly brushing it throughout the wash. While it is still wet, load your brush with some Payne's Gray and brush it into the Moonglow in various spots. Let the two colors blend and bleed together. Work quickly and, if needed, dab a little water on your piece to continue working the two colors together. Next, add some Bordeaux to the wet Payne's Gray and Moonglow in random spots. You can encourage the blending of the colors with a little water on your brush. Let the paper dry.

2. Repeat Step 1 to create a small oval-shaped swash of paint on the right side of your journal spread. Apply a wash of water in an oval shape. Then add the colors and move the paint around with more water. Let the colors bleed out over the oval's edge to make it look more organic. Let the paper dry completely.

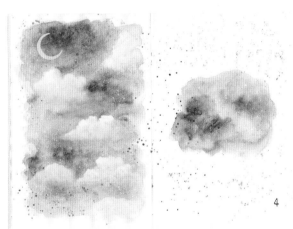

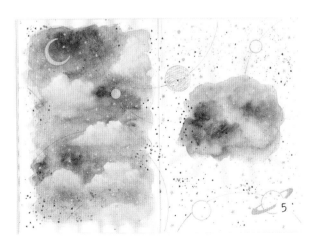

3. Load a size 0 brush with some slightly diluted Moonglow and make stars by tapping your brush above both pages of your journal spread. Concentrate on the white areas of the journal spread more than on the areas you just painted in Steps 1 and 2. Repeat the technique with Bleedproof White to make more stars. Concentrate the white stars over the painted areas instead. Now you should have both purple and white stars scattered across your spread. Let the stars dry.

4. Create some clouds on the left page by loading a size 6 brush with some slightly diluted Bleedproof White. Start dabbing in a few clouds just as you have in other projects. Your clouds should appear lighter at the top and get a little darker toward the bottom of the cloud. To achieve this effect, keep the clouds saturated with Bleedproof White at the tops and then, using more water on your brush, blend the white out toward the bottom of the clouds. Add about five clouds and space them out. Then, use your circle maker tool and a white pen to draw a small crescent moon shape in the upper left corner of your painting. Load a size 4 brush with more slightly diluted Bleedproof White to paint the crescent moon.

5. Use your circle maker tool and a metallic silver pen to draw some large rings, almost like half circles across both pages. Draw them as though they are popping onto your page from the edges of the paper, overlapping them. Next, with the circle maker tool and a metallic silver pen, draw some planets with the various sizes on your circle maker tool. Draw them on the ring lines you just made so it looks like the planets are orbiting. Fill in some of your planets with the metallic silver pen and leave some of them just as an outline. Draw Saturn's rings and add some bands in Jupiter with the same pen. Lastly, hand-draw some stars all over both sides of your journal spread with both a metallic silver pen and a white pen.

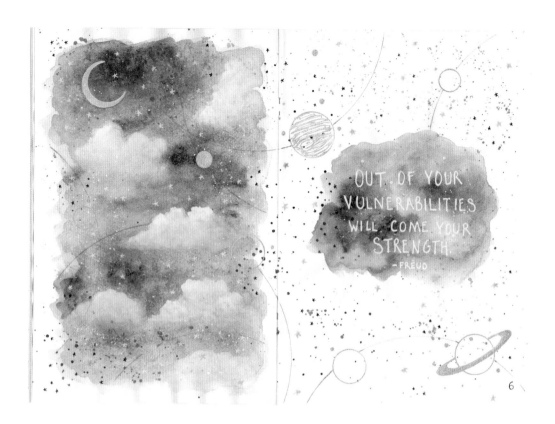

OUT OF YOUR VULNERABILITIES WILL COME YOUR STRENGTH.
—FREUD

6. Finally, pick a quote that you love and handwrite it with a white pen on the right side of your spread where you painted the oval-shaped swash of color. I chose the quote "Out of Your Vulnerabilities Will Come Your Strength," by Sigmund Freud. You can choose the same quote if you wish!

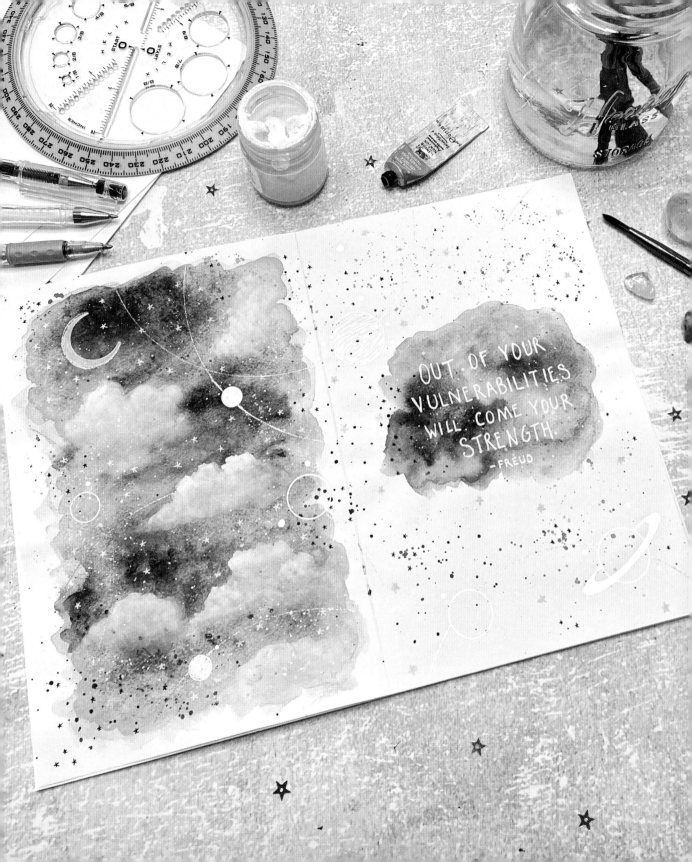

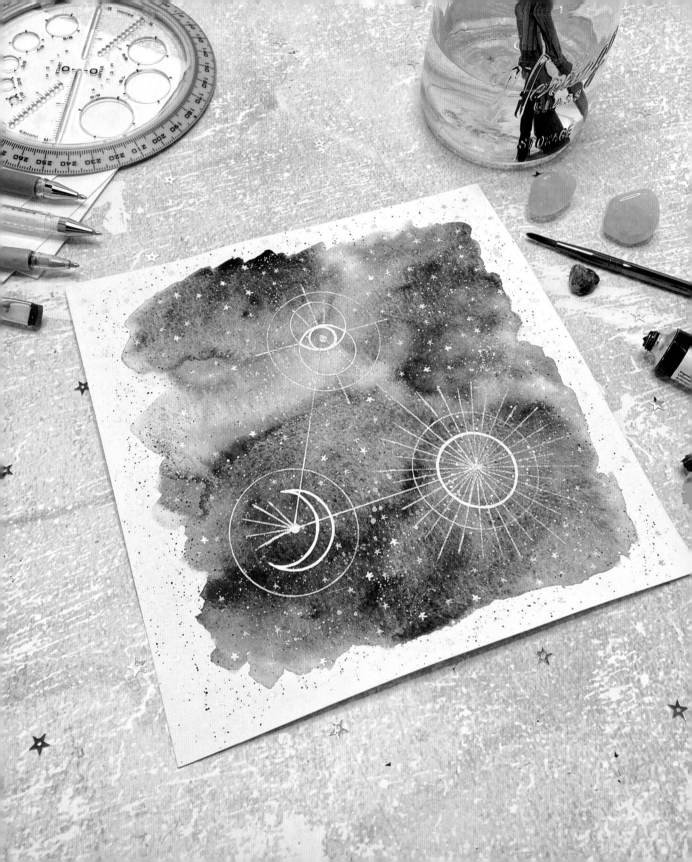

CREATING COSMIC SYMBOLS

We all have memories or objects that have meaning in our lives, and it is emotionally beneficial for us to hold on to those things forever, kind of like souvenirs of our most significant moments. We can create symbols that represent those meaningful moments, and they can become very beautiful pieces of artwork. Not only are these pieces lovely to look at, but their special meaning adds sentimental value. I use a lot of symbols in my art to represent the things that are important to me and that hold some spiritual value. Circles are very significant in my art because I believe that they are the framework of life. Circles and cyclic patterns are everywhere. Triangles are another significant shape in my life, representing the past, present and future.

My favorite project in this chapter has to be Soul Circle Art (page 148). As a young adult, I used to doodle infinite circles inside of one another and create patterns of circles on pieces of paper. I would add details to the circles such as rings, planets or florals. I kept a lot of my old drawings, and unearthing those circle doodles inspired me to create the Soul Circle Art project. I found it to be very soothing and relaxing!

INTUITIVE SYMBOL

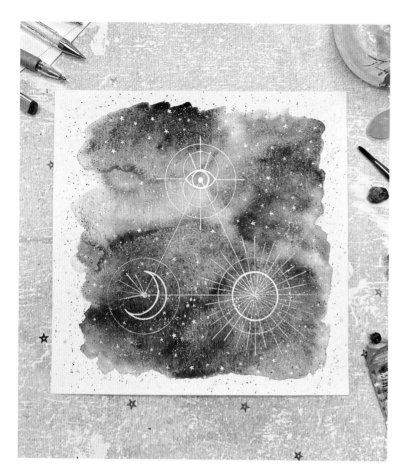

I like to add symbols to some of my art that represent parts of my life and that I find spiritual in nature. An intuitive symbol can be any design you assign meaning to. I particularly like to add circles to my art because I feel that everything is connected in the universe. In this project, you are going to paint some symbols of your choosing that have meaning to you. I am going to show you how I created this project with the symbols I chose—the sun, the moon and the inner eye—and you are most welcome to use the same.

Supplies

Paintbrushes, sizes 0 and 8

8 x 8" (20 x 20-cm) sheet watercolor paper

Metallic silver pen (I used a Pentel Sparkle Pop Pen and a Uni-Ball Signo Pen)

Ruler

Circle stencil tool

Circle maker tool

White pen (I used a Uni-Ball Signo Pen)

Color Palette

 Daniel Smith Moonglow

 Daniel Smith Bordeaux

 Dr. Ph. Martin's Bleedproof White

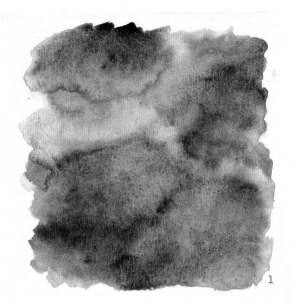

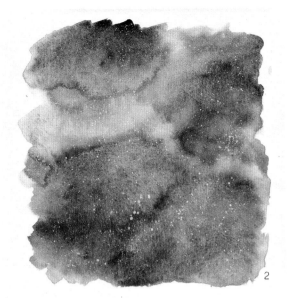

1. Load a size 8 brush with water and apply a wash of water all over the page, leaving about a ½-inch (1.3-cm) border dry. Load the brush with Moonglow and brush it all across the wet area of the paper. Mix equal parts of Moonglow and Bordeaux to create a violet-red color and dab it throughout the Moonglow you just applied. Let the colors blend and bleed together, adding a little more water if needed. Let the paper dry.

2. Once dry, load a size 0 brush with some slightly diluted Bleedproof White and tap the end of your brush all over your paper to create a star effect. Let the stars dry.

3. Start drawing your intuitive symbol with a metallic silver pen, ruler and a circle stencil tool. Start with a triangle in the middle of the paper and then draw three (2-inch [5-cm]) circles at the points of the triangle. Line up the circle stencil tool so that the points of the triangle are centered inside the circles, then trace the circles with a metallic silver pen.

4. Use a metallic silver pen and a circle maker tool to draw a crescent moon in the bottom left circle and another circle inside the circle on the bottom right. Then, at the top of the triangle, draw what I like to call "the eye of pi." To draw the eye of pi, create a small circle that is centered with the tip of your triangle, so the point of the triangle is directly in the middle of the circle. Then choose a larger circle on your circle maker tool and place it around your smaller circle so that the bottom edge of the bigger circle touches the bottom edge of the smaller circle. Draw the circle and repeat the same process for the bottom half of the symbol, so that the top of the bigger circle touches the top of the smaller circle. Draw the second circle, and you should be left with an eye shape in the middle of your circles.

5. With a ruler and metallic silver pen, draw rays extending out from the middle of both the crescent moon and the sun. Define the eye of pi a little more by adding a pupil in the very middle that is at the top of the triangle. Then add three lines extending out from the top, one extending out from the bottom and one extending out from both sides of the eye.

6. For some finishing touches, use a white pen to add white stars throughout the painted background. Then go in with a metallic silver pen and make stars on the outside of the painted area, along the border. Lastly, load a size 0 brush with some slightly diluted Moonglow and tap the brush along the white border of your piece to create some purple stars. Do not add too much water to the paint or the stars will end up too big.

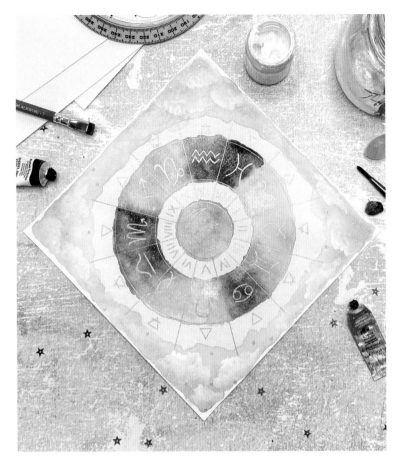

ASTROLOGY WHEEL

An astrology wheel is a great reference to have. The one you'll create in this project will include the twelve astrological signs and the elements they represent. My favorite part about this project is painting the actual wheel itself and blending all the beautiful colors together. It's very satisfying! Once you complete your wheel, you could frame it or keep it in a journal.

Supplies

Ruler

8 x 8" (20 x 20-cm) sheet watercolor paper

Pencil and eraser

Circle maker tool

Paintbrushes, sizes 0, 4, 6 and 8

Metallic gold pen (I used a Sakura Gelly Roll Pen)

Color Palette

 My Vanilla Mix (page 16)

 My Peach Mix (page 16)

 My Pink Mix (page 16)

 Daler-Rowney Aquafine Gold

 Daniel Smith Moonglow

 Daniel Smith Payne's Gray

 My Teal Mix (page 16)

 Dr. Ph. Martin's Bleedproof White

1

2

1. Find the middle of your paper by measuring 4 inches (10 cm) on each side of your paper and making a light mark with a pencil. Line up your circle maker tool directly in the middle of the page. Use your circle maker as a guide by lining up 0 degrees with the upper pencil, 90 degrees with the right mark, 180 degrees with the bottom mark and 270 degrees with the left mark. Draw around the entire circle maker. With your circle maker still in place, find the 1½-inch (4-cm) dot in the middle where you can place your pencil to draw a 3-inch (7.5-cm) circle. Essentially you will be drawing a small circle in the middle of the large circle you just drew. Still keeping the circle maker tool in the middle of your paper, find the ¾-inch (2-cm) dot to place your pencil and draw a third circle measuring 1½ inches (4 cm). Keep the circle maker in place.

2. Next, you are going to divide up your circles like a pie. With the circle maker still in place, make light pencil marks around the outside every 30 degrees. Use a ruler to connect each mark to its opposite on the other side. When you are finished, you will have six lines total and twelve pie slices.

3a

3b

3. Each astrological sign is associated with an element—fire, earth, air or water. I painted my astrological wheel with colors I felt represented each of those elements (3a). I used peach for fire signs, pink for earth signs, purple for air signs and blue for water signs. To help you paint the colors in the wheel that identify with each of the elements, label your pie sections with the elements. Aries is the first sign in the wheel, which is a fire sign, so start with fire, then earth, air and water. Repeat that pattern all the way around your wheel. You should end on water.

Start by loading a size 6 brush with My Vanilla Mix and a little Peach Mix and apply it to the outermost portion of the first pie section. While that is still wet, brush some Pink Mix into the outermost portion of the second pie section. Use some water to blend and mix the colors where the first and second pie sections meet (3b). Load the brush with some Gold paint and brush it over your Vanilla Mix. Then load the brush with Moonglow and apply it to the outermost portion of your third pie section. Take some water and blend the colors together where the second and third pie sections meet. Load the brush with some Payne's Gray and apply it to the outermost portion of your fourth pie section, again using some water to blend the colors together where the third and fourth pie sections meet. For the fifth pie section, start over with the Vanilla Mix and Peach Mix like you did in the first pie section and repeat the four-color pattern all the way around your wheel until you end up back at the top. Don't worry if you go over your pencil lines a little. Let the paper dry completely.

4. Load a size 6 brush with water and apply a wash to the inner, smallest circle on your wheel. Fill in the circle with My Teal Mix. Again, don't worry if you go over the lines with a little paint. Next, load a size 8 brush with some water and apply a wash to the background around the outermost circle of your wheel. Leave just a little bit of space between your background and your wheel. Then load the same brush with some Teal Mix and apply it to the background, adding more color where you need. Let the paper dry.

5. Start painting some clouds on the teal background around the wheel by loading a size 4 brush with Bleedproof White and dabbing in some clouds. As in previous projects with clouds, keep the tops white and blend them down toward the bottom with water to create dimension. Load a size 0 brush with some slightly diluted Bleedproof White and tap the brush over the paper to flick stars all over your painted areas. Do not add too much water to the paint or your stars will get too big.

NUMERAL	SIGN	SYMBOL	ELEMENT
I	ARIES	♈	△
II	TAURUS	♉	▽
III	GEMINI	♊	△
IV	CANCER	♋	▽
V	LEO	♌	△
VI	VIRGO	♍	▽
VII	LIBRA	♎	△
VIII	SCORPIO	♏	▽
IX	SAGITTARIUS	♐	△
X	CAPRICORN	♑	▽
XI	AQUARIUS	♒	△
XII	PISCES	♓	▽

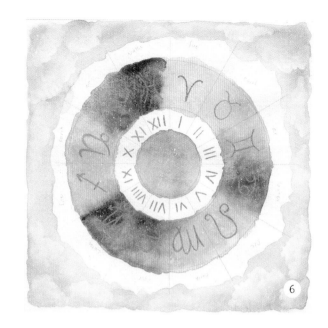

6.

6. Next, you're going to draw the symbols for each astrological sign and the roman numerals that correspond to each sign's place on the wheel, referencing the chart to the left.

Use a metallic gold pen to draw each symbol in the outermost portion of each pie slice. The first sign in the wheel is Aries, a fire sign, so start with Aries where you painted the color for fire. Rotating clockwise around your wheel, follow the chart to add your symbols to each pie slice until you end with Pisces, which is a water sign. Just underneath each of your signs, in the white, unpainted portion of each pie slice, write in the roman numeral that each sign corresponds to using the metallic gold pen.

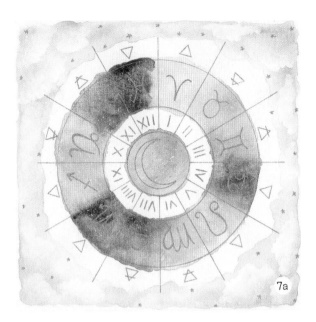

7a

7. To add the final details, use the circle maker tool and a ruler to trace over all the pencil lines in your wheel with a metallic gold pen (7a). Also use the metallic gold pen to draw the symbols for fire, earth, air and water (7b). Erase any words or marks that you wrote to help you paint the circle in Step 3. The fire sign is a triangle and the earth sign is an upside-down triangle with a line through the bottom quarter. The air sign is a triangle with a line through the top quarter, and the water sign is just an upside-down triangle. Repeat this pattern all the way around your wheel. Use a circle stencil to draw a crescent moon in the middle of your wheel and add some dots of gold with your metallic gold pen. Lastly, add some gold stars throughout the teal background with the gold pen.

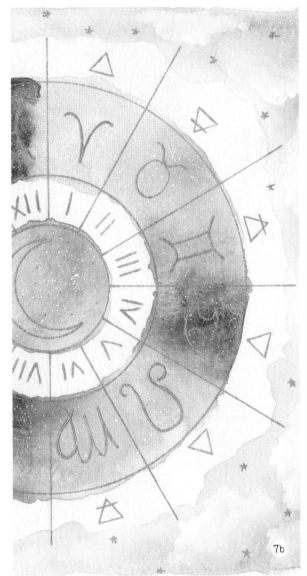

7b

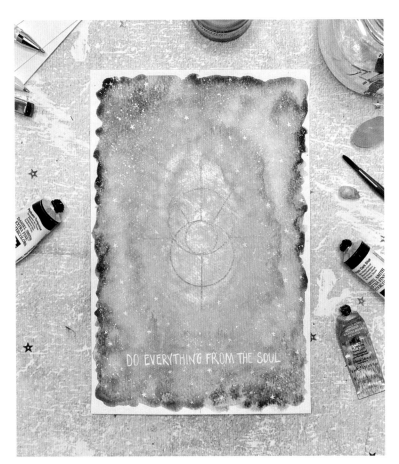

YOUR SOUL'S MANTRA

Everyone should have a mantra in life. A mantra is something you truly believe in and that you seek to reinforce in your life every day. If you don't already have one, take a few minutes to think of one. It doesn't have to be long; it could be just a few words that you put together. It can be anything that inspires you to live a good life. My mantra is "Do everything from the soul" because it's something I truly believe in and strive for in my life. Once you find a good mantra, you are going to make a piece of art to showcase it. You are more than welcome to use my mantra for your piece.

Supplies

Paintbrushes, sizes 0 and 8

6 x 9" (15 x 23–cm) sheet watercolor paper

Metallic gold pen (I used a Sakura Gelly Roll Pen)

Circle maker tool

Ruler

White pen (I used a Uni-Ball Signo Pen)

Color Palette

 My Pink Mix (page 16)

 Daler-Rowney Aquafine Gold

 My Teal Mix (page 16)

 Daniel Smith Mayan Blue Genuine

 Dr. Ph. Martin's Bleedproof White

1. Load a size 8 brush with My Pink Mix and paint an oval shape in the middle of your paper. Add water to expand it out slightly and add more pink as you need. Then dab some Gold paint into the very center of the oval shape, on top of the pink. Next, load your bush with My Teal Mix and brush it around the pink oval without touching the pink paint. Spread out the teal until it almost extends to the edges of the paper, applying water and more Teal Mix as needed. Work quickly. While the pink is still wet, load your brush with some water and connect the pink and the teal so that they bleed and blend together. You can add more water or color as you need it when blending these two colors, but let them bleed into one another. While the teal is still wet, load your brush with some Mayan Blue Genuine and brush it on the very edge of the teal, almost to the edge of your paper, to create a darker area. Let the teal and Mayan Blue Genuine blend together, then let the paper dry completely.

Once dry, load a size 0 brush with some slightly diluted Bleedproof White and flick stars all over the background by gently tapping the paintbrush over the paper. Do not add too much water to the paint or your stars will end up too big. Let the paper dry.

2. Use a metallic gold pen and a circle maker tool to draw the eye of pi. Make a ⅞-inch (2-cm) circle in the center of the pink oval. Then make two 1¾-inch (4.5-cm) circles to create the rings that go around the small ⅞-inch (2-cm) circle you just drew. Line up the 1¾-inch (4.5-cm) circle stencil so that the bottom of the circle touches the bottom of the smaller circle and trace around the stencil. Do the same thing for the second ring, except this time the top of the small circle should line up with the top of the circle stencil. You should have what looks like an eye in the middle.

3. With a ruler and the metallic gold pen, add some detail around the eye. Draw rays coming out of the eye to represent the light that comes from within. Draw four straight lines extending out from the sides, top and bottom of the eye. Next to the line on top of your eye, draw a line on each side that is slightly diagonal to your ruler. Then add gold dots at the end of each line.

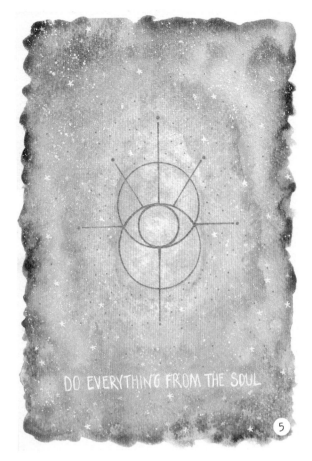

4. Use a white pen to freehand write your mantra at the very bottom of your inner eye symbol. If you need to write it out in pencil first to get it evenly spaced on the page, do so, but do it very lightly so you can erase the pencil lines if you need to. If you cannot think of a mantra of your own, you are welcome to use mine!

5. Finally, add in some stars with the white pen all around your piece.

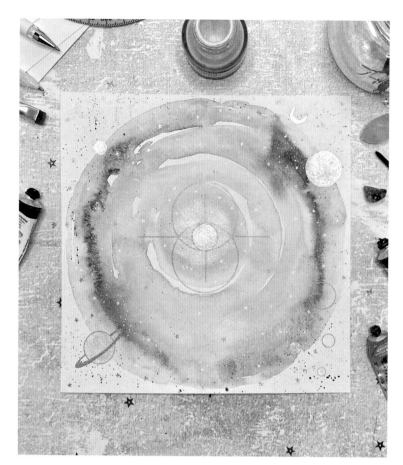

SOUL CIRCLE ART

This project should bring you some relaxation. Don't overthink it—it's more about making simple brushstrokes and meditating on the colors blending together than the composition. You're basically going to paint circles around circles and let the colors blend into one another. Then you can embellish the circles with anything, but I like to add a cosmic touch with some planets, of course. These are called "soul circles" because they represent the cycles in your life and what is important to you, but the process is also good for the soul!

Supplies

Paintbrushes, sizes 0, 6 and 8

8 x 8″ (20 x 20-cm) sheet watercolor paper

Circle maker tool

Metallic gold pen (I used a Sakura Gelly Roll Pen)

Circle stencil tool

Ruler

White pen (I used a Uni-Ball Signo Pen)

Color Palette

 My Teal Mix (page 16)

 Daler-Rowney Aquafine Gold

 My Pink Mix (page 16)

 Daniel Smith Moonglow

 Dr. Ph. Martin's Bleedproof White

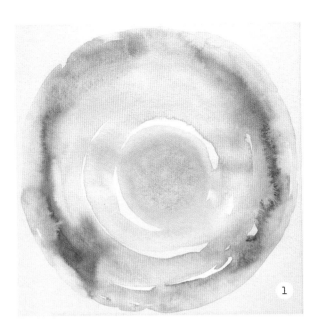

1. Load a size 6 brush with My Teal Mix and paint a circle in the middle of your paper with it. Dab some Gold paint directly in the middle of the circle. Use a little water to spread the teal circle outward slightly. Load a size 8 brush with My Pink Mix and apply it around the Teal Mix, just barely touching the teal in spots. Use some water to encourage the colors to blend and bleed. Expand the pink with more watercolor and a little water by brushing more strokes of pink around the teal. While the pink is still wet, load your brush with Moonglow and use the same technique—applying the paint around the pink so that the colors just barely touch. Use some water to encourage the colors to blend and bleed. Expand this circle with more paint and water to the edge of your paper. Let it dry.

2. Load a size 0 brush with some slightly diluted Moonglow and tap the brush all over the outer edge of your circles to make tiny purple stars. Do the same with some slightly diluted Bleedproof White to create white stars. Do not add too much water to the paint or your stars will end up too big. Let the paper dry.

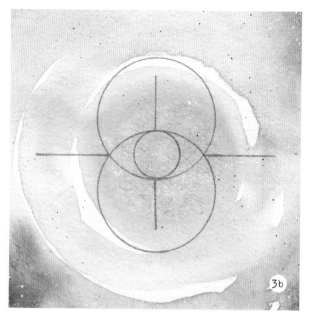

3. You can choose any symbol you'd like to draw in the middle of this background, but I chose the mind's eye or the eye of pi (3a). Use a circle maker tool and metallic gold pen to draw a ¾-inch (2-cm) circle in the center of your page. Then use a circle stencil tool and the metallic gold pen to draw two larger 1⅞-inch (5-cm) circles around the smaller circle. Line up the bottom of the smaller circle with the bottom of the 1⅞-inch (5-cm) circle stencil to make the first ring. Then line up the top of the smaller circle with the top of the 1⅞-inch (5-cm) circle stencil to make the second ring. You should have what looks like an eye in the middle (3b). Draw four lines extending out from the top, bottom and both sides of the eye with a ruler and the metallic gold pen.

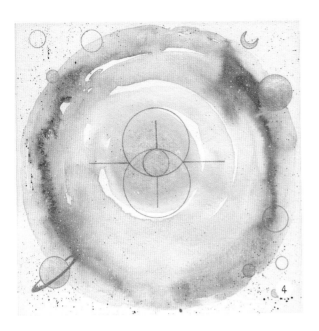

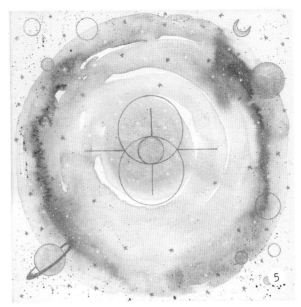

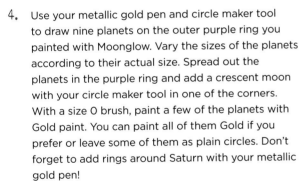

4. Use your metallic gold pen and circle maker tool to draw nine planets on the outer purple ring you painted with Moonglow. Vary the sizes of the planets according to their actual size. Spread out the planets in the purple ring and add a crescent moon with your circle maker tool in one of the corners. With a size 0 brush, paint a few of the planets with Gold paint. You can paint all of them Gold if you prefer or leave some of them as plain circles. Don't forget to add rings around Saturn with your metallic gold pen!

5. Lastly, add some stars with a white pen throughout your circles. Then go in with your gold pen and add more stars all over the entire piece.

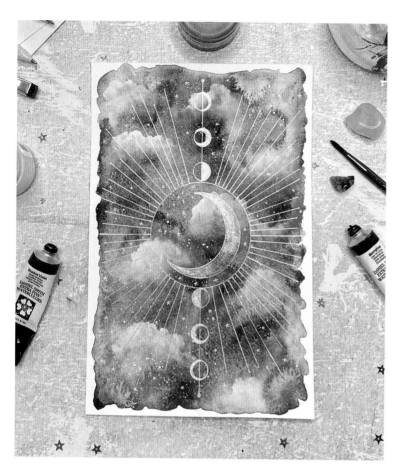

GEOMETRIC MOON SYMBOL

I think the moon is the most beloved symbol in my life, and it's a significant part of my art. I find myself always drawn to gazing at the moon every night that I can see it in the sky. There is definitely something magical and very soothing about the moon—it's a constant in life, even as everything else around us comes and goes. For this project, you're going to draw the moon and its phases as one symbol. When finished, it will make another beautiful display piece to hang on your wall.

Supplies

Paintbrushes, sizes 0, 4 and 8

6 x 9″ (15 x 23–cm) sheet watercolor paper

Metallic gold pen (I used a Sakura Gelly Roll Pen)

Circle stencil tool

Ruler

Pencil and eraser

Circle maker tool

White pen (I used a Uni-Ball Signo Pen)

Color Palette

 Daniel Smith Moonglow

 Daniel Smith Shadow Violet

 Dr. Ph. Martin's Bleedproof White

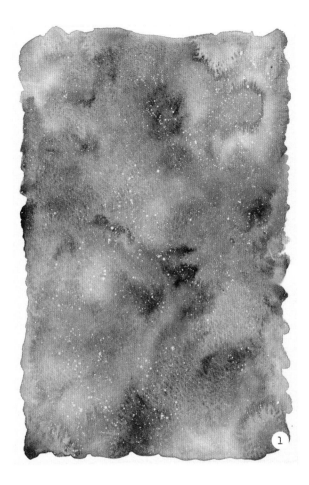

1. Load a size 8 brush with water and apply a wash all over your paper, being careful not to spill any water over the edges. Load your brush with Moonglow and brush it across the wet paper in various spots but do not cover the entire background with it. Work quickly. While the paper is still wet, load your brush with Shadow Violet and dab it onto the various unpainted spots so that it begins to blend and bleed together with the Moonglow. You can add more color or water to encourage the colors to blend. Let the paper dry.

2. Load a size 4 brush with Bleedproof White and dab some tufts of clouds throughout your background. Keep the clouds opaque white at the top and then blend them out with water toward the bottom to give them depth. Spread out the clouds around your page. Next, load a size 0 brush with some slightly diluted Bleedproof White and tap the end of your brush all over your page to create some dots of stars. Do not add too much water to the paint or your stars will end up too big. Let the paper dry.

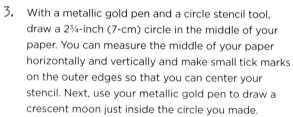

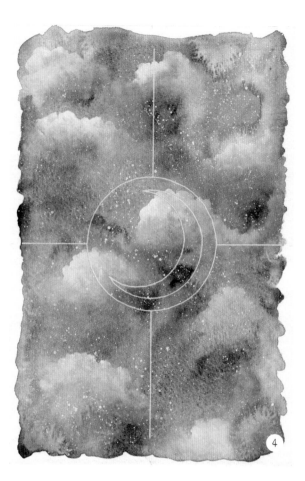

3. With a metallic gold pen and a circle stencil tool, draw a 2¾-inch (7-cm) circle in the middle of your paper. You can measure the middle of your paper horizontally and vertically and make small tick marks on the outer edges so that you can center your stencil. Next, use your metallic gold pen to draw a crescent moon just inside the circle you made.

4. Draw rays extending out around the circle with your gold pen and a ruler. Start with a total of four rays extending out from the top, bottom, left and right.

5. Next, use your circle maker tool and metallic gold pen to draw three ½-inch (1.3-cm) circles on the top line that are evenly spread out and centered on the line and three more on the bottom line. The first circle should already be split in half because you centered it on the line. For the second circle on both the top and bottom, draw a crescent moon that is a thicker crescent shape. The crescent on your top circle faces the left side of your paper and the crescent on the bottom line faces the right side of your paper. Then, for the third circle on both the top and bottom, draw a very thin crescent in each. Draw them facing the same way you drew the previous crescent on the same line. Load a size 0 brush with some Gold paint and fill in your crescents and half-moons. Also paint your large crescent that is in the middle of your paper.

6. With a ruler and your metallic gold pen, add in the rest of the rays extending out from the circle. Move your ruler around your circle and draw lines all the way around it, leaving some space in between them.

7. Finally, use a white pen to draw some stars all throughout your piece.

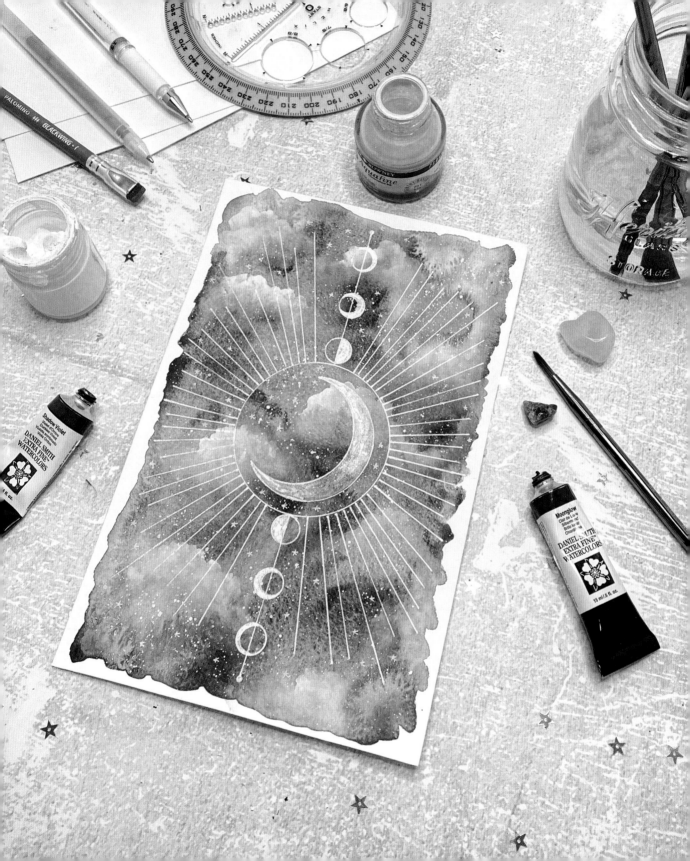

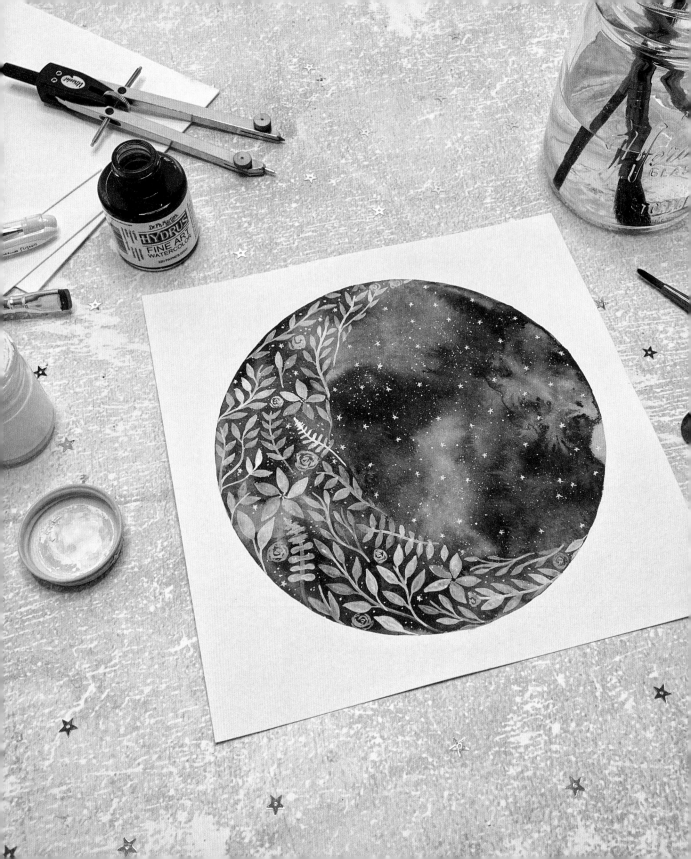

ACKNOWLEDGMENTS

Writing a book has always been a dream of mine, and I couldn't have done it without these people supporting me through the process. First, I want to thank Page Street Publishing for making this dream come true, along with Madeline Greenhalgh and Ashley Casteel for all their help and patience.

My mother has always been a very strong woman, and I've watched her accomplish so much no matter what obstacles have tried to stop her. I want to acknowledge this incredible woman who has taught me so much and raised me to be strong like her.

Throughout the process of creating this book in the year that has been the worst year for many, I often called on friends and family for assistance. Everything from childcare, grocery shopping and sometimes just a friend to talk to. I am forever grateful for your help.

I want to thank my husband for putting up with the dreamy world I live in and for believing that I could create something good for the world. Chad has been there to support me in many ways, and I am eternally thankful for that.

I can't thank my kids enough for being patient and curious while I fulfilled this dream. It's been challenging this year with Covid-19, virtual school and pushing forward with life through it all. My kids have done a phenomenal job helping me navigate my dreams while their world has gone through so many challenges.

Finally, I want to thank my social media family that has shown so much support and encouragement for my work. I truly couldn't have done this without all of you.

ABOUT THE AUTHOR

Sosha has a love affair with watercolor, illustrating and the universe. She's been an artist and a dreamer since she was a child. She remembers coloring for hours, creating things that her family couldn't buy and always looking up at the sky wondering what was out there. She was initially dissuaded from exploring art as a career option in college and did not pursue it as anything more than a hobby.

Moving to a suburb of Chicago in a leap of faith, she obtained a BA in Fine Art from North Central College, despite all the reasons she'd been told to avoid an art career. Later, she continued her studies in graphic design at Harrington College of Art and Design in downtown Chicago. As her life evolved, so did her dreams. She became passionate about the connection she felt to creating. She wanted to be more than a graphic designer and wanted to be an illustrator as well. In pursuing those dreams, she has had the amazing opportunity to illustrate a subscription box for the Sunday Riley beauty company, in addition to illustrating a few books, like *Moon Power* by Merilyn Keskula-Drummond and *The Complete Book of Dreams* by Stephanie Gailing.

When Sosha is not busy pursuing her dreams, she spends time with her family, reads about science, takes walks through the woods, sits upon her meditation pillow, gazes up at the stars and of course paints with watercolors! She is a native of Michigan, although she hasn't lived there all of her life. She spent almost the other half of her life in Chicago, but both places hold special spots in her heart. She has a son, Jaxon, a daughter, Jori, a husband, Chad, an American bulldog named Dozer and one goldfish with no name that has been with the family for six years!

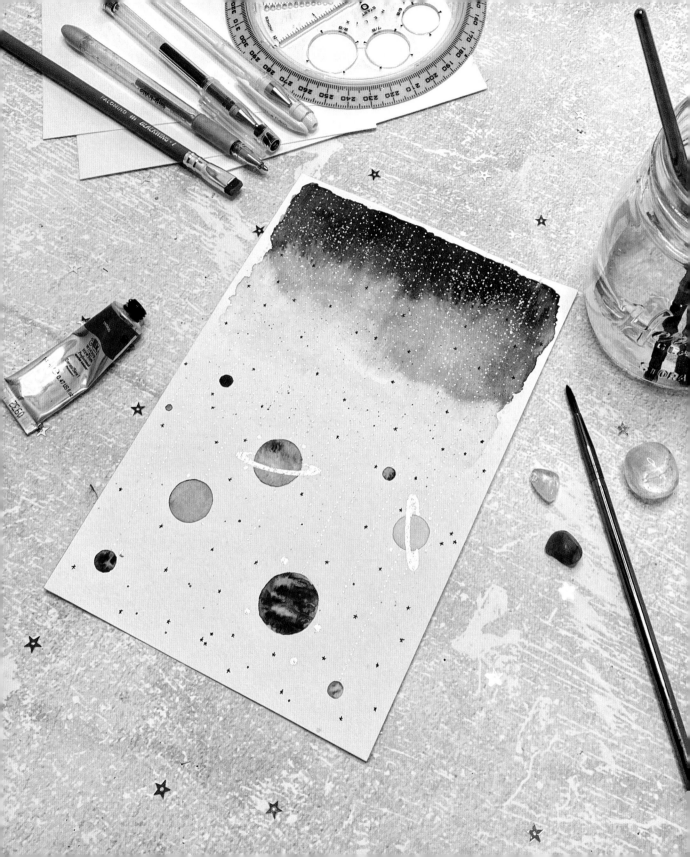

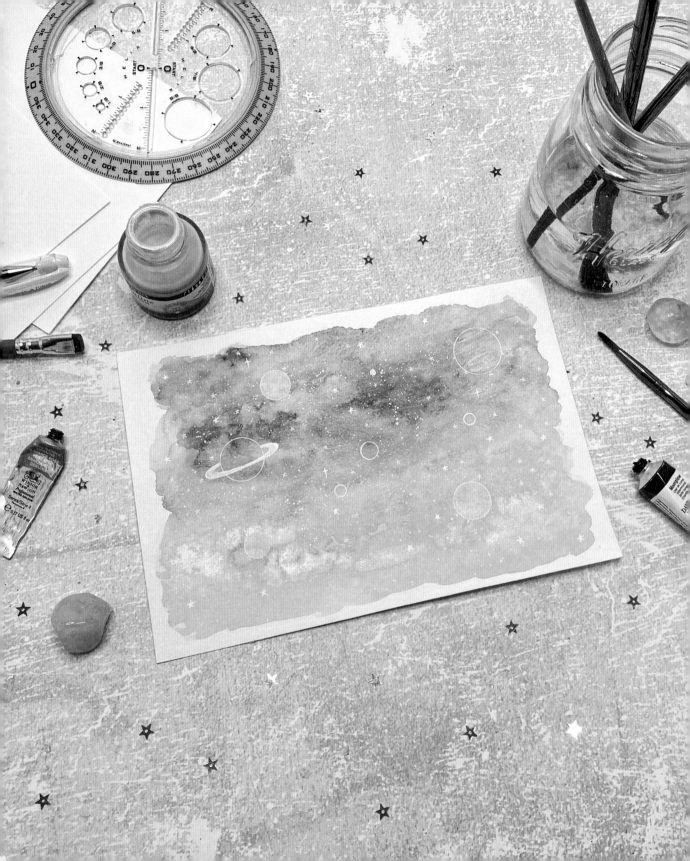

INDEX